IMAGES
of America

LOCUST VALLEY

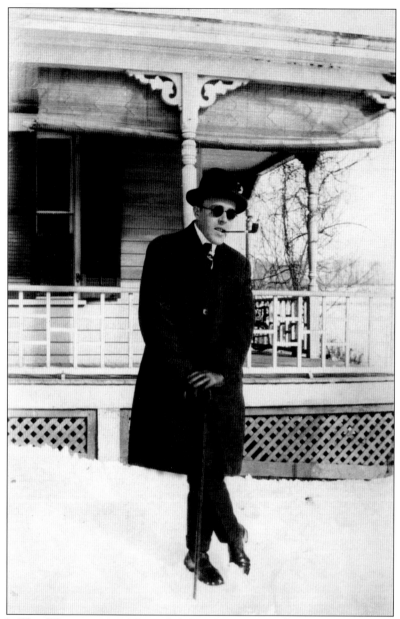

HOWARD A. VAN WAGNER, 1917. Howard A. Van Wagner stands in front of the family home on Buckram Road. After America's entry into World War I, Van Wagner enlisted in the 6th Regiment Engineers in October 1917. He died of wounds received at the front at a base hospital in France on July 28, 1918. Howard A. Van Wagner American Legion Post 962 is named in his honor. (Courtesy of Linda Bruder.)

ON THE COVER: LOCUST VALLEY TRAIN STATION, 1943. The Locust Tower operator hands orders to the engineer on locomotive No. 311. The Long Island Railroad was extended to Locust Valley in 1869, bringing economic development to the isolated farm community. Restoration of the wooden signal tower was spearheaded by the Matinecock Neighborhood Association and completed in 2006. (Courtesy of Ron Ziel Collection, photography by James R. Boerckel.)

IMAGES of America

LOCUST VALLEY

Joan Harrison and Amy Dzija Driscoll
Introduction by Herb Schierhorst

ARCADIA
PUBLISHING

Published by Arcadia Publishing
Charleston, South Carolina

Printed in the United States of America

Library of Congress Control Number: 2011938168

For all general information, please contact Arcadia Publishing:
Telephone 843-853-2070
Fax 843-853-0044
E-mail sales@arcadiapublishing.com
For customer service and orders:
Toll-Free 1-888-313-2665

Visit us on the Internet at www.arcadiapublishing.com

We dedicate this book to Joel Stein, a friend to Locust Valley for more than 80 years. Joel has served Locust Valley and his country as a veteran, firefighter, postman, and postmaster. Having raised his family in his hometown, he continues to educate and inspire the community through his selfless work with the Locust Valley Historical Society. Joel is always available for a question, and his quick responses are always on target.

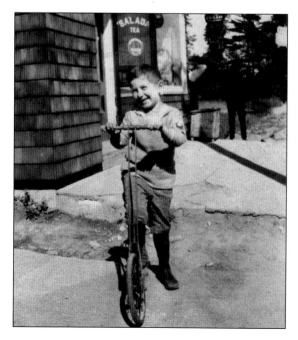

JOEL STEIN, 1923. In this photograph, young Joel Stein stands before his parents' store on Birch Hill Road. A child of immigrants, he achieved the American Dream in Locust Valley and embodies the best characteristics of the community. (Courtesy of Joel Stein.)

CONTENTS

ACKNOWLEDGMENTS

First and foremost, we thank Janis Schoen, the former director of the Locust Valley Library, and her staff for their enthusiastic support of both this book and of the Locust Valley Historical Society, headquartered in the Julia B. Clarke History Room. We are indebted to the Locust Valley Historical Society, especially Eileen Casey and George Shaddock for their exacting red-pencil edits and knack for unearthing just the perfect photograph. Current and past residents of Locust Valley were extremely generous and trusting in allowing us use of their personal photographs. Special thanks go to Ron Ziel for our cover image and to Joel Stein, Victoria Ward, Eunice Johnson Winslow, George Holland, Ann Lotowycz, Eve Califano, Susan Hillberg, Miani Johnson, Edward Armstrong, Barry Osborn, Paul J. Mateyunas, and Linda Bruder for sharing pictures, memories, and personal tours of unique corners of the community. Thanks also go to Carol Harrington, Jesse Albert Mould, Mary Jane Lippert, Bill Tabler, Clarence Michaelis, Kathy Picoli, and Herb Schierhorst for their editorial advice. It is a testament to the character and the values of these friends who not only never refused a request for help but also met the queries with referrals that led to even more photographs and stories. Marion Baker and her son and daughter in-law, Jeff and Jessica Baker, were early supporters of this book and provided a steadfast stream of photographs and introductions. We thank the Underhill Society, Friends Academy, Locust Valley Fire Department, and Grenville Baker Boys and Girls Club for opening their archives and scrapbooks for us.

Finally, we would like to thank our families—Michael Ach, Emily and Chloe Harrison-Ach, and Timothy, Maddie, and Timmy Driscoll—for their unwavering patience, support, and love.

Photographs from private collections are credited as such. All other images are from the Locust Valley Historical Society Collection.

INTRODUCTION

In a picturesque valley along the road from Musketa Cove to Oyster Bay, a small village grew up beside a spring-fed brook called Chagechagon. In 1730, with the establishment of a post office in the Davis General Store, this bit of countryside consisting of a few settlers' homes, several merchants, and a blacksmith shop became known as the village of Buckram.

The early settlers sustained themselves by clearing land, planting crops, and harvesting fish, oysters, clams, and sea turtles from the surrounding waters. They dammed creeks to impound waters in order to run the saw, grist, paper, and cider mills and the fulling mill that produced coarse fabric called buckram. The first school, a one-room frame building, stood at the entrance to Kaintuck Lane on Oyster Bay Road. Soon outgrown, in 1801, a larger Matinecock School was established nearby on Ryefield Road, located on the present-day site of the bus parking lot of the Locust Valley Intermediate School.

In 1856, over local objection, Buckram was renamed the more physically descriptive appellation, Locust Valley, after the abundance of locust trees lining its byways and its geographic location in a valley. In 1900, an attempt to rename it Matinecock failed.

On April 19, 1869, the railroad arrived with the railhead spur terminating at the south end of Bayville Road. The end point, known as Bayville Station, was located where the electrical substation is today, four miles from the actual town of Bayville. From this point on, farmers shipped their crops to the city by train, and rail freight arrived from New York to meet community needs. An official train stop was established one mile west of old Buckram with a turntable and engine house. Growing businesses started to situate around the train station, and the Locust Valley commercial district as it is known today began to form.

The old village and its historical homes along Buckram Road were absorbed into Locust Valley, retaining its quaint character for the next hundred years. Residents of Locust Valley made their livelihoods as farmers, baymen, laborers, boardinghouse owners, tavern and inn keepers, dry goods merchants, millers, blacksmiths, tinsmiths, ministers, teachers, and doctors. Light industry began in the area with the mills and continued with the farmers building canneries to market local produce, the first of which was located in Lattingtown. Other industry in the region included brass polishing, carpet weaving, rug hooking and a hat factory.

Each summer in the 1890s, John D. Hendricks, a famous guide and pathfinder of Locust Valley, would show large numbers of Brooklyn and New York tourists the best sights in the beautiful village and surrounding areas. All agreed that Pleasant Valley, as early Lattingtown was called, was the prettiest place on the North Shore of Long Island. Adjacent Peacock Point was considered to be the most desirable place to spend a day by the sea.

At the end of the 19th century, wealthy families from New York City began to purchase large tracts of land to build their weekend estates and fulfill their baronial fantasies. Attorneys William Dameron Guthrie and Paul Drennan Cravath joined forces to buy up farms around Lattingtown and construct their country houses. The area soon became home to John E. Aldred's Ormston,

7

George and Edith Baker's Vikings Cove, and Henry P. Davison's Peacock Point. The Gold Coast came alive in all its glory.

Publisher and Mill Neck resident Frank Nelson Doubleday and friends saw a need for a community center to deal with social and civic concerns, and in 1908, they raised funds to establish the Matinecock Neighborhood Association. A suitable building was erected on Buckram Road and served as a firehouse, a place to meet for a play, a movie, a game of bowling, or to read a book. It became the social center and library for the larger community. Today, this building is the Locust Valley Library. The Locust Valley Historical Society is located in a section of the old caretaker's quarters on the upper floor.

By the late 1920s, there were over 40 estates in Locust Valley. A 1928 referendum to incorporate the hamlet was defeated by voters who preferred to limit taxes and keep things as they traditionally were. The Great Depression of 1929 led to the end of the era of grand estates, and many of the larger country properties were broken up. After World War II, housing developments were built, and Locust Valley became a bedroom community, with many of its inhabitants commuting by rail to the city.

Today, the sense of civic pride and community participation remains strong. Shortly after World War II, citizens of Locust Valley spearheaded the initiative Operation Democracy to send supplies to Sainte Mere Eglise, the first town liberated during the invasion of Normandy. Within a year, nearly 200 American cities had followed Locust Valley's lead, adopting cities all over the world. These programs continue today as the Sister Cities, formally created by President Eisenhower in 1956. With the 2010 documentary *Mother of Normandy*, the rekindled Operation Democracy seeks to carry on this legacy from a humanitarian, nonpartisan perspective.

The postwar period also saw the genesis of the Grenville Baker Boys and Girls Club, first named the Associated Boys Club of Locust Valley, Inc. The club remains an integral part of Locust Valley and continues to inspire and develop our youth. Locust Valley Historical Society treasurer George Shaddock fondly remembers attending Camp Small Fry at the Pratt Estate in Glen Cove. Today, club excursions venture farther afield, but the emphasis on learning and development remain.

Despite change and the passing of the years, Locust Valley is still the most desirable and beautiful area of the North Shore, and the little hamlet at the depot remains the hub and the heart of the larger community. We are a garden flourishing in rich soil sown and nurtured by our founders who valued education, beauty, and civic pride. We invite you to visit our town and explore this unique juxtaposition of history and modern community.

—Herbert W. Schierhorst, president
Locust Valley Historical Society

One

MATINECOCK

Mid-17th-century settlers to Locust Valley built their houses along Bayville Road and the lanes of Mill Neck. Originally inhabited by the Matinecock tribe, the area was called by the same name, a descriptive term meaning "land that overlooks." The old region of Matinecock encompassed present-day Locust Valley and the incorporated villages of Lattingtown, Matinecock, and Mill Neck. The first colonists were millers, baymen, and farmers who predominantly grew onions and asparagus.

Prominent early settler Capt. John Underhill came from England in 1630 and married Elizabeth Feke. They established a homestead called Killingworth in Matinecock. Elizabeth was a devout Quaker and persuaded her husband to convert. Underhill died at Killingworth in 1672 and was buried on a hillside off Factory Pond Road. The thoroughfare was named for the factory built on Killingworth's pond that was created by the damming of Corn Creek. In the early 20th century, Myron C. Taylor, chairman of US Steel, whose mother was an Underhill, owned the property. Taylor had the pre–Civil War house rebuilt into the English country manor he felt befitted an Underhill and established a trust to support the Burying Ground in perpetuity.

In 1667, seven men—Robert Williams, John Dyer, William Simson, Henry Reddocke, Christopher Hawxhurst, Mathew Priar, and Nathan Birdsall—purchased land from the Matinecocks between East Island and Mill Creek in a transaction that came to be known as the Seven Deed Purchase. Other first families included the Frosts, Fekes, Lattings, Townsends, Downings, Weeks, and Wrights. In the 1690s, John Feke sold his Underhill land that later became the incorporated village of Lattingtown. One of the purchasers, Joseph Weeks, gave the southern portion to his son, who built a house that still stands on Oyster Bay Road.

Early Quakers like the Underhills were extremely committed to their faith and organized a monthly meeting in 1671, as well as the building of a meetinghouse in 1725. Matinecock Friends is recognized as having the oldest continuous Friends meeting in the United States. The building at the crossroads of Duck Pond and Piping Rock Roads is the heart of present-day Matinecock, which became an incorporated village in 1931.

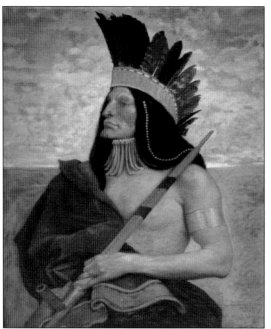

MATINECOCK CHIEF, 1928. Winslow S. Pierce, president of Matinecock Bank, commissioned this oil painting of a Matinecock chief by George de Forest Brush. It was a revered symbol of the community for generations. When the bank, then a branch of Bank of America, closed in 2009 residents wrote letters to keep the painting in the community. It is now in the collection of Nassau County Museum of Art.

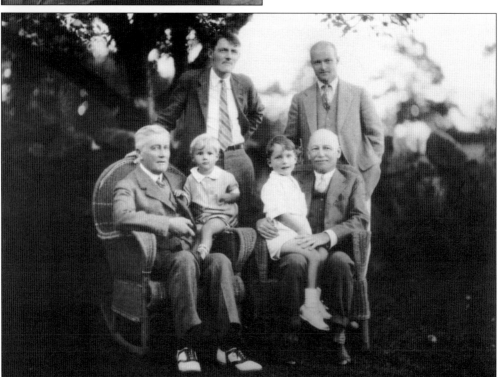

THREE GENERATIONS, 1928. Winslow Shelby Pierce Jr., who posed for the arm of the Matinecock chief in the de Forest Brush painting, stands on the left with Stuart Johnson standing at right. Seated in the front row are Winslow S. Pierce (left) with grandson Bill Pierce on his knee and community leader F. Coit Johnson holding his grandson Stuart Johnson Jr. (Courtesy of Eunice Johnson Winslow.)

CORN CREEK. The damming of Corn Creek formed Factory Pond at Killingworth. It was on the edge of this pond that the buckram cloth factory was built. Allegedly, regimental uniforms were fabricated there during the American Revolution. (Courtesy of the Underhill Society.)

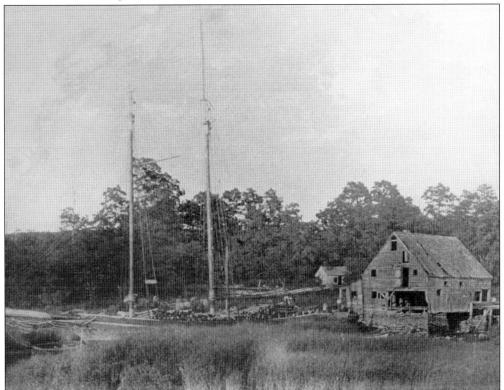

BEAVER DAM MILL. In 1694, the first sawmill was built at Beaver Swamp "Crick" by John Feke. Feke's partners were Henry Townsend Jr., who was most likely the miller, and Samuel and William Birdsall. Mills were an integral part of early Matinecock life.

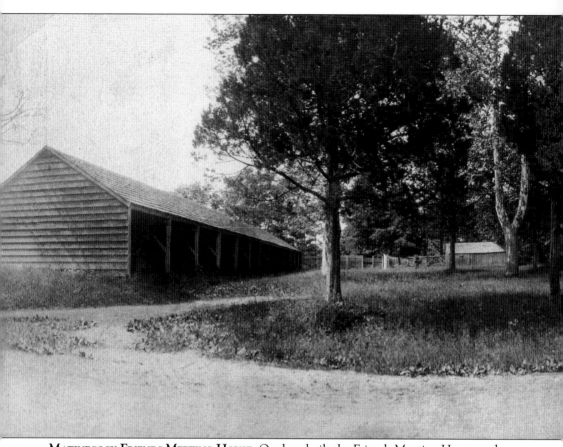

MATINECOCK FRIENDS MEETING HOUSE. Quakers built the Friends Meeting House at the corner of Piping Rock and Duck Pond Roads in 1725. The two-story building, which was two bays wide, four bays long, and topped by a steeply pitched roof, was listed in the National Register of Historic

Places in 1976. Although the building was gutted by fire in 1985, the structure was rebuilt to the exact specifications of the original.

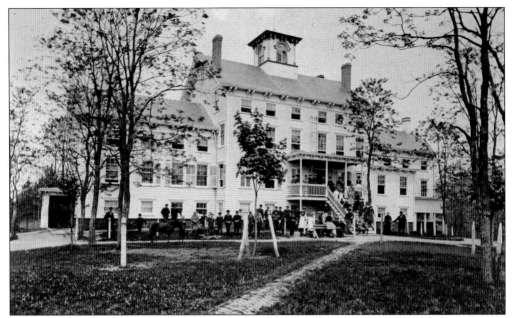

Friends College, 1884. In 1876, Gideon Frost, a Quaker businessman with an interest in science, bought six acres of land opposite Matinecock Meeting House and founded Friends College. Frost, a lifelong opponent of war and capital punishment, spoke out against both. He believed children of Friends and others "similarly sentimented" should receive literary and scientific instruction in accordance with the teaching of the Scriptures. (Courtesy of Friends Academy Archive.)

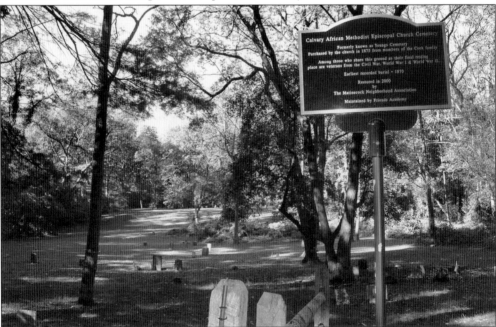

Youngs Cemetery. In 1875, the Calvary African Methodist Episcopal Church of Glen Cove acquired Youngs Cemetery on Piping Rock Road from William T. Cock, his wife, Hannah, and Samuel Cock for the burial of Civil War–era church members and veterans. The cemetery was restored in 2000 by the Matinecock Neighborhood Association.

Hon. Townsend D. Cock. Townsend Cock was born in Locust Valley on his ancestral farm in December 1838 and attended both the district school and Lot Cornelius's private school. Cock was president of the Oyster Bay Bank and served the community as supervisor of the town of Oyster Bay, state senator, and member of assembly. Known as a scientific farmer, he was president of the Queens County Agricultural Society from 1879 to 1881.

Cock-Cornelius House. This Quaker homestead, dating from 1790 with later additions, has also been known as the Jarvis Underhill homestead, the Stage Coach Inn, Hay Fever, and the Cock-Cornelius house. It has been a private home, a store, Lot Cornelius's school, a Colonial restaurant, and a newspaper office. It was listed in the National Register of Historic Places in 2006 and is once again a private residence.

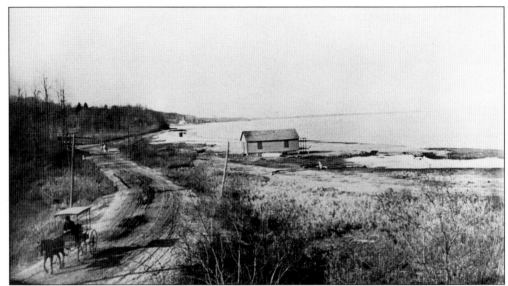

West Shore Road. One of the oldest roads in old Matinecock, West Shore Road hugs the western edge of Oyster Bay, from the southeastern edge of Mill Neck outside the town of Oyster Bay, to Bayville. The marshy area was often impassable in stormy weather due to tidal surges, and eventually, a seawall was built and the roadbed raised and paved. (Courtesy of the Underhill Society.)

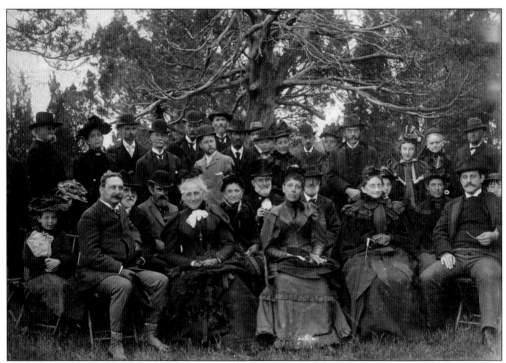

Underhill Family Meeting. The second annual meeting of the Underhill Society of America was held in the Underhill Burying Ground. Capt. John Underhill was buried under a cedar tree. The cemetery, formally organized in 1843 and incorporated in 1909, is still in use. Burial rights may be obtained with proper proof of Underhill ancestry. (Courtesy of the Underhill Society.)

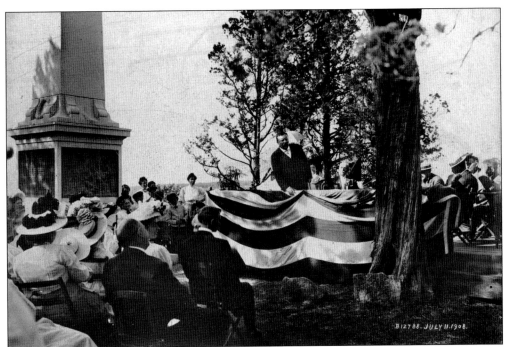

DEDICATION OF THE UNDERHILL MONUMENT, 1908. Pres. Theodore Roosevelt joined D. Harris Underhill at the dedication of the obelisk honoring Capt. John Underhill. The Underhill Burying Ground, located off Factory Pond Road, was established in 1672 with the interment of noted Colonial military leader Capt. John Underhill. At the monument dedication ceremony, Roosevelt gave an address, "A Good Soldier and a Good Citizen." (Courtesy of the Underhill Society.)

MYRON C. TAYLOR. Myron C. Taylor, a descendant of Captain Underhill and chairman of US Steel, created an endowment for the perpetual maintenance of the Underhill Burying Ground. He was personal envoy to Pope Pius XII during the Roosevelt and Hoover administrations. Here, he is pictured in his automobile at his ancestral home Killingworth. (Courtesy of the Underhill Society.)

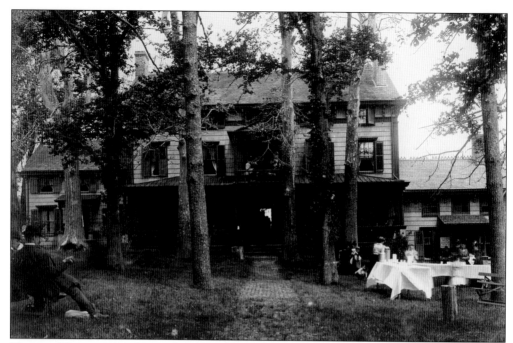

HOLIDAY HOUSE, 1896. Located on the corner of Feeks Lane and Factory Pond Road, Benjamin Downing's Holiday House offered country respite to working girls from the factories and sweatshops of New York City. Originally the homestead of the Feeks family, the house burned to the ground on Christmas afternoon in 1911. (Courtesy of the Underhill Society.)

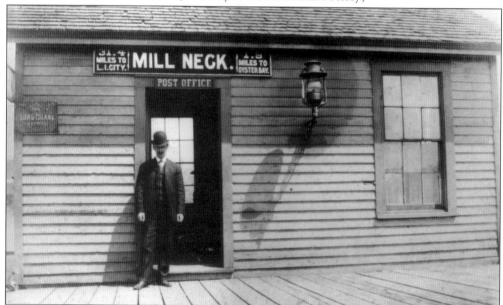

MILL NECK STATION. In 1889, the railroad was extended from Locust Valley to Oyster Bay and a Bayville stop was established near Holiday House. The misnamed station was moved east and renamed Mill Neck, as previous visitors had arrived only to find themselves several miles from Bayville. The station, no longer an active stop, now serves as Mill Neck's post office, village hall, and police station.

Two

BUCKRAM

By the late 1600s, descendants of the early Matinecock settlers had built homesteads along Oyster Bay and Buckram Roads. Buckram, as a place designation, first appeared in 1741. Oyster Bay records state that George Frost was elected overseer of highways "for Buckeram." There are two schools of thought on the origin of the name: first, that it derived from Buckenham, the Underhill ancestral home in Norfolk England; second, that it was drawn from buckram, a kind of cloth produced in area mills.

Buckram's boundaries, in current landmarks, were from the arched bridge opposite Kirk's blacksmith shop to the trestle below Barney's Corner on Oyster Bay Road. The area to the east, consisting of Ayers, Cocks, and Pershing Avenues, was known as Buckram Heights. Buckram was more densely populated than the rest of old Matinecock and had a small town center with stores where Buckram and Bayville Roads intersect.

Buckram Road began as a Matinecock footpath that followed the banks of Chagechageon Brook. It became an official road in 1703 when the Town of Oyster Bay made a "Divition of the Land on ye West Side of the highway by Joseph Weeks Jnr." The families who were assigned lots have familiar names: Weeks, Underhill, Frost, Cocks, Birdsall, Hawxhurst, Prior, and Fekes. The Chagechageon still runs next to the Hawxhurst House. The Hawxhurst family operated a mill on the Chagechageon and used the stream to float logs to the sawmill on Kaintuck Pond. The mill powered by the Kaintuck produced buckram, a fabric used in making clothing.

In the 1890s, blight destroyed the farm crops in the area, particularly the asparagus, and left the ground unsuitable for replanting. Farming declined, and the mills began to disappear. Wealthy men from the city bought up the countryside for weekend homes and baronial estates. Although Buckram continued to have shops, restaurants, and a gas station well into the 1960s, the town center migrated westward towards the railroad depot where the hamlet of Locust Valley is located today.

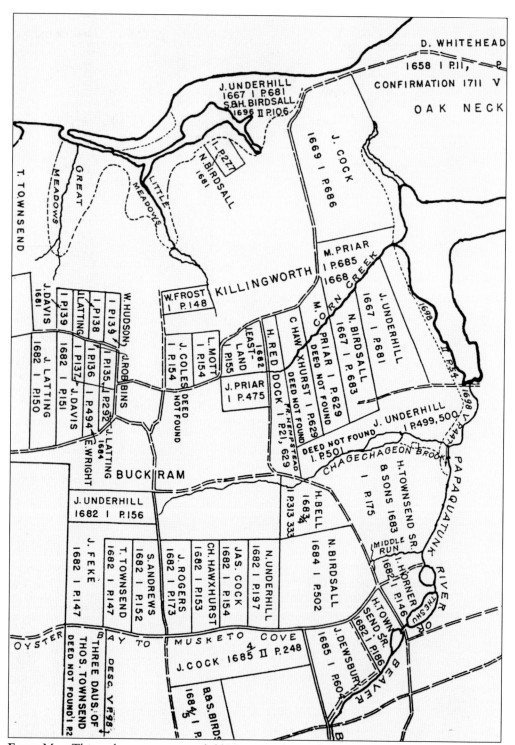

EARLY MAP. This early property map of old Matinecock reveals the names of the first landowners. The Buckram section can be seen prominently in the central portion of the map, showing Feke, Townsend, Andrews, Rogers, Hawxhurst, Cock, Underhill, and Birdsall properties.

20

BARNEY. William H. "Barney" Burnett became foreman of the Locust Valley Fire Department in 1895, after two years of service as assistant foreman. Despite the fact his estimated weight was between 400 and 600 pounds, he was an active fireman. According to local lore, he was known to eat 17 eggs, a porterhouse steak, and several quarts of milk at a sitting.

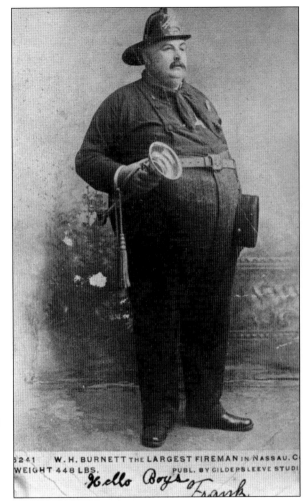

BARNEY'S CORNER. In 1905, Barney Burnett's tavern was built at the crossroads of Oyster Bay and Bayville Roads after the fire that burned out the Wansor property. The present-day restaurant in the building displays his mammoth-sized belts on the wall.

21

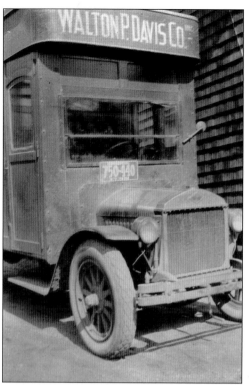

WALTON P. DAVIS MOVING AND STORAGE. During the 19th century, Walton P. Davis, located in the heart of old Buckram, rented horses and buggies to visitors arriving by train. Company employees also worked as carpenters, electricians, and horse transporters for those who came to live in the area. The company, which incorporated in 1914, evolved into one of the first moving companies on Long Island.

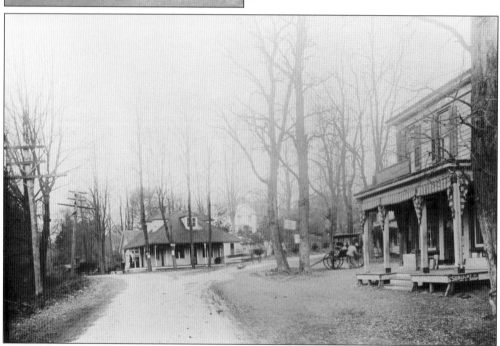

DAVIS GENERAL STORE. The Davis Store, a Town of Oyster Bay Landmark, seen to the right, was located on the northeast corner of the main crossroads. In the early 19th century, it also served as the post office. To keep children occupied while their parents shopped, Davis nailed a penny with a copper nail to the counter and announced anyone who could pick it off could keep it.

TOWNSEND BAILEY WEEKS II, 1888.
Born in Buckram on September 7,
1868, Townsend Bailey Weeks II
was a talented instrument maker
who crafted the banjo he is seen
playing in the image. He turned
his skills to the fabrication of the
community bobsleds, including
the victorious *1911.* (Courtesy of
Townsend W. Cardinale.)

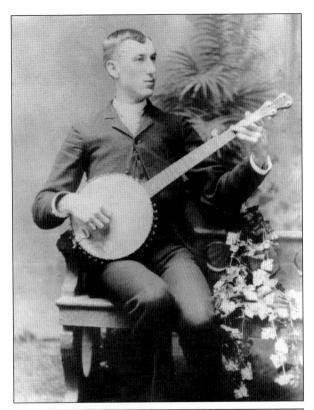

TEAMMATES. Bobsledding was a favored Buckram sport during long snowy winters. Pictured from
left to right, sledders Ike Wansor, Arthur Williams, unidentified, and Markey Hendrickson stand
in front of their sled. The best local sledding course was on School House Hill.

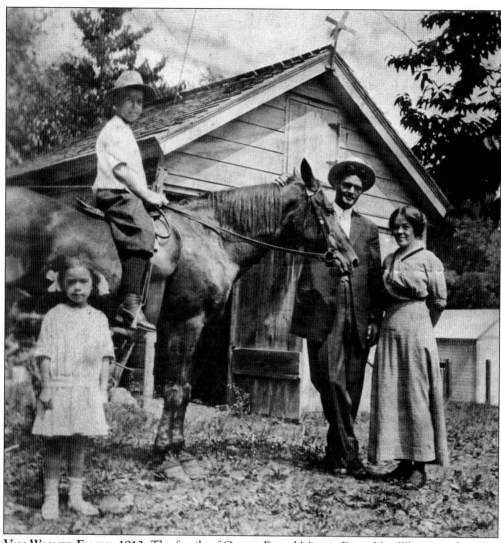

VAN WAGNER FAMILY, 1913. The family of George E. and Minnie Davis Van Wagner gathered at their Buckram home in the summer of 1913 for this photograph. From left to right are Evelyn, Harry (on horse), Oliver "Tex" Purser, and his fiancée, Phebe Van Wagner. (Courtesy of Linda Bruder.)

FIRLING ATHLETIC CLUB MEMBER, 1912. The Firling Athletic Club began in a rented room on the third floor of Poggi's store in 1910. Charles Firling was president, Thomas Murphy vice president, Thomas Wade was treasurer, and John White was the team captain. Club members fielded baseball and basketball teams and, in 1913, formed a brass band. The band and the teams later merged with the fire department.

POGGI'S STORE. This popular fruit and vegetable store was located next to the railroad tracks on Birch Hill Road. The pool hall was next door. Proprietor Poggi was an active member of the local Firling Athletic Club that met there. The store was destroyed by fire on June 15, 1928.

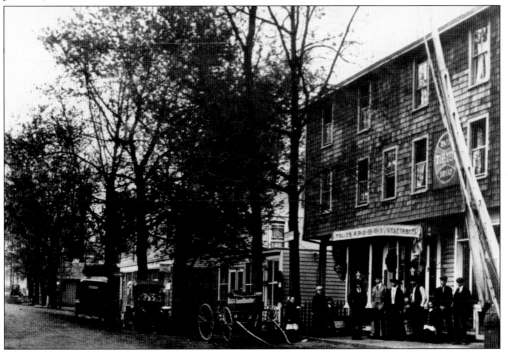

ANTONIO BOZZELLO, 1940s.
Antonio Bozzello immigrated
from Paduli, Italy, and raised
his family in Buckram Heights.
Antonio was a farmer and often
worked as a groundskeeper on
the nearby Church Estate as
well as at Piping Rock Club.
(Courtesy of Marion Baker.)

BOZZELLO'S STORE. This
neighborhood grocery store
on Oyster Bay Road was
presided over by Philamena
Cekala for over 60 years.
Although technically located in
Matinecock, its closing in the
1990s was lamented by Buckram
Heights residents. In earlier
times, it was the site of a hooked
rug factory owned by Joe Fisher.
(Courtesy of Marion Baker)

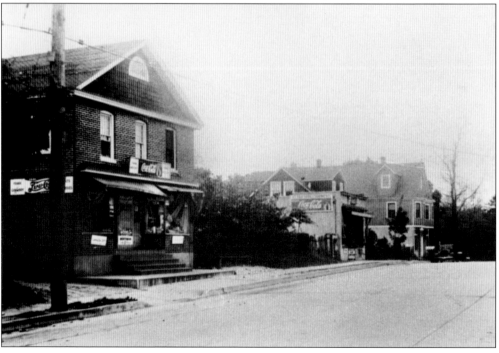

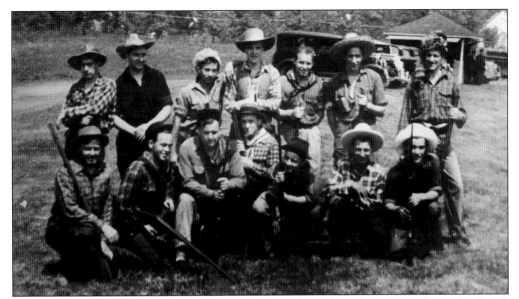

PIONEER CLUB, 1939. The Pioneer Club began in 1923 when a dozen boys met in August Jacobsen's garage. It was primarily a sporting club with teams participating in baseball, football, hockey, bowling, and track. Shortly after forming, members built a clubhouse on Pershing Avenue. The original clubhouse burned in 1928, but the rebuilt structure remains today. Here, members are dressed in full pioneer regalia. (Courtesy of Jeff Baker.)

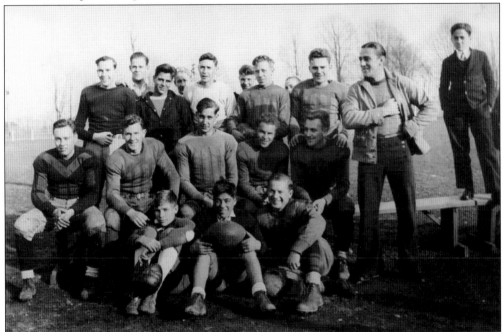

PIONEERS FOOTBALL TEAM, 1930S. The Pioneers were the local favorites and the hometown football team in Buckram. Seen in their group portrait are, from left to right, (first row) Bill Fehr, Baldy Daniello, and Bill Mills; (second row) Bill Rosenburg, Bob Simpson, Ken Dudley, Vic Greenberg, and Ed Weeks; (third row) Jim Robertson, Ed Cormier, Joe Daniello, unidentified, Tom Aitchison, John Gregory, Ernie Keller, unidentified, G. Novatny, Herb Heath, and Emil Keller.

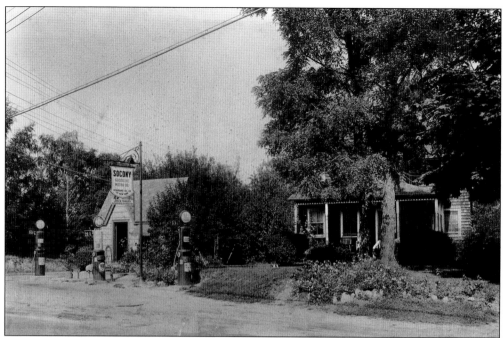

SHADDOCK GARAGE, 1950s. This garage, owned by the Shaddock family and located on Oyster Bay Road at the corner of Cocks Lane, opened as a Socony distributor in 1926 and closed in 1970. (Courtesy of Janice Deegan.)

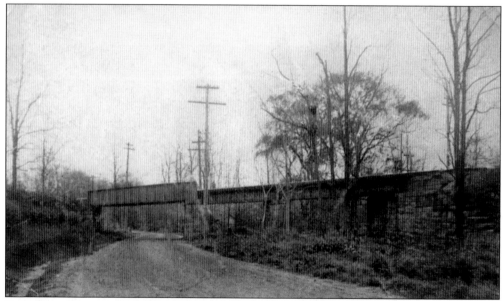

RAIL ROAD TRESTLE. Built in the 1870s as the first leg of the Long Island Rail Road journey to Oyster Bay, the bridge, a building project that took 20 years, had to be made much wider than normal to accommodate the Chagechagon Brook. The bridge marks the eastern boundary of old Buckram.

LONG ISLAND RAIL ROAD BRIDGE. One of the defining architectural landmarks in Locust Valley is the beautifully engineered arched bridge that transports Long Island Rail Road trains over Town Cocks Lane on their journey east to Oyster Bay. The brick arch was completed on April 13, 1888, over what was then called Tunnel Street. The above view faces north towards the building that was once Kirk's Blacksmith shop and is presently a private residence. The below view looks toward the south.

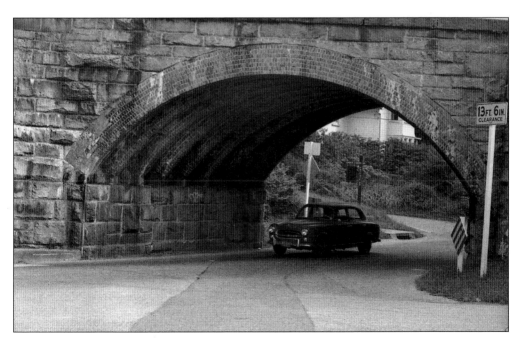

WILLIAM E. Kirk. William E. Kirk Sr. apprenticed as a blacksmith in Ebenezer Cocks's shop at the age of 19 before becoming proprietor of the store, the oldest business in Buckram, in 1845. Located opposite the brick trestle on the north side of Buckram Road, the shop shod as many as 35 horses a day and manufactured carts and wagons for local farmers.

INVOICE, KIRK'S BLACKSMITH SHOP. This 1918 bill, rendered to Zebulon Wilson of Lattingtown from William E. Kirk's blacksmith shop, was for the considerable sum of $176.94. Horseshoes and sundry necessities were itemized. At that time, the business offered horseshoeing, carriage ironing, and general blacksmithing services.

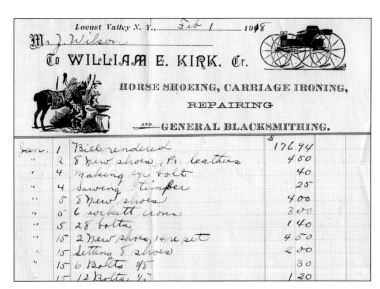

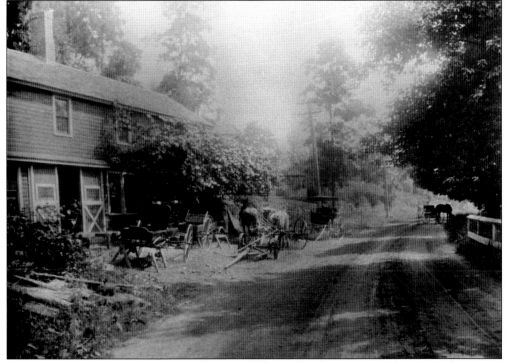

STREET VIEW, BLACKSMITH SHOP. In this view of the smithy shop, its general store can be seen on the right-hand side of the building. Two of the famous Locust Valley bobsleds and an Alexander Calder sculpture were constructed on the premises. In its last years, lawn mower repair and the sale of antiques and hand-wrought items kept the business afloat.

LEADER OFFICE. This view looking north on Birch Hill Road shows a house that served briefly as the post office and later as the *Locust Valley Leader* office. Meserole's Stables, seen in the background, was consumed by fire on Christmas Eve in 1922. Thirty horses perished in the blaze.

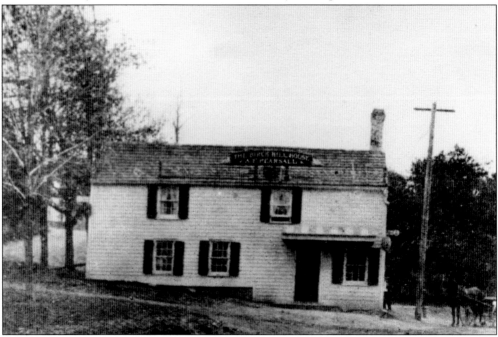

BIRCH HILL HOUSE. A.P. Pearsalls's Birch Hill House stood on the corner of Ludlam Lane and Birch Hill Road. At different times, the building was an inn, a saloon, an ice cream parlor, and was even utilized as a Catholic Sunday school.

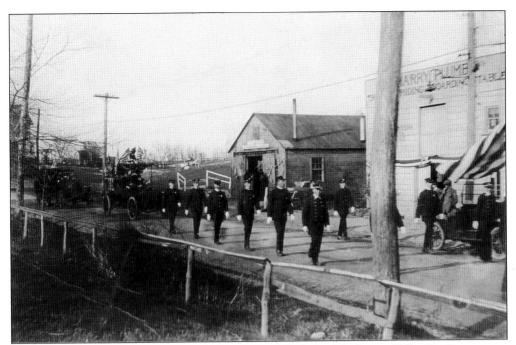

FIRE DEPARTMENT PARADE, BIRCH HILL ROAD, 1917. Members of the Locust Valley Fire Department marched over the raised roadway that once formed Birch Hill Road in the Memorial Day parade. The view looks northeast towards the location of the present-day shopping center.

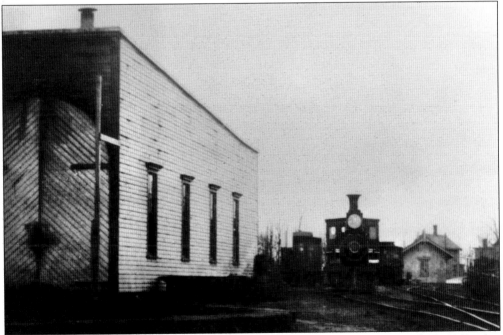

LOCUST VALLEY DEPOT, 1878. Train service to Locust Valley began on April 19, 1869, after the extension of the railroad from neighboring Glen Cove was completed. Early New York photographer George Bradford Brainerd photographed the depot and roundhouse. The engine house and turntable originally came from Jamaica station.

CASEY COUSINS, 1912. Cousins Joe Casey (left) and Mike Horan are shown here with the Namm's Department Store wagon. Around 1910, brothers John and Joe Casey established a delivery service. Residents ordered dry goods from Brooklyn department stores that would arrive by rail. The Casey brothers would then meet the trains, sort the parcels in their barns on the corner of Baldwin Avenue and Davis Street, and deliver them. (Courtesy of Eileen Casey.)

Three

LATTINGTOWN

In the upper reaches of old Matinecock bordering the Long Island Sound, Richard Latting acquired land from Matinecock chiefs Suscannemon and Werah. He subsequently deeded it to his son Josiah, who made a living gathering reed from the salt marsh to be sold for roofing thatch. The generations that followed enlarged the 1690 Latting cottage and continuously inhabited the property for nearly three centuries. The last Lattings to live at Werah Farms were Helen Latting Dudgeon and Alice "Effie" Latting Van Namen, who relinquished the ancestral home in the 1970s.

The community that grew up in the Latting area consisted primarily of asparagus farmers and baymen who collected scallops and hard clams from the riches of Dosoris Pond. Known first as Pleasant Valley, then as Latting Town, the tiny hamlet consisted of roughly 60 structures including the Davis and Wilson stores and a nondenominational Christian chapel, located along Pudding Lane, now Lattingtown Road.

By the late 19th century, estates began to replace Colonial farms. Prominent Manhattan lawyer Paul Drennan Cravath bought the Frost farm to build Veraton, his palatial country home. Public utilities tycoon John E. Aldred and attorney William Guthrie purchased adjoining properties to build their respective estates, Ormston and Meudon. They also bought the old village of Latting Town and razed it to ensure their estate entrances had picture-perfect views of the bucolic countryside. The wood-frame Union Chapel was replaced with a brick edifice and came under the auspices of the Episcopal Church. This became the parish of St. John's of Lattingtown. The village of Lattingtown was officially incorporated in 1931 with William Guthrie as mayor and town offices located at Meudon.

In an 1850 letter to her mother, Harriet A. Emerson Latting described Lattingtown as "this delightful retreat of quiet and shade." To this day, Lattingtown remains a place of great natural beauty, as well as an exclusive enclave steeped in tradition and privacy. The community celebrated the anniversary of present mayor Clarence Michaelis's 40th year in office in 2009.

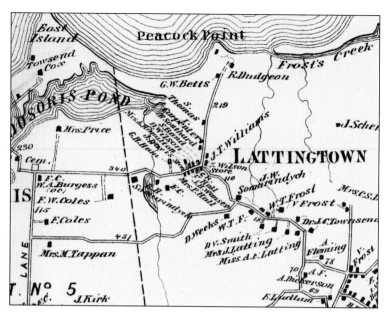

BEERS, COMSTOCK, & CLINE MAP, 1873. Zebulon Wilson's and Epp Davis's stores, a few homes and the Union Chapel along Pudding Lane, now Lattingtown Road, made up the original community of Lattingtown. Residents made their living clamming on Dosoris Pond and working in the asparagus cannery operated by George J. Price Jr. in neighboring Dosoris.

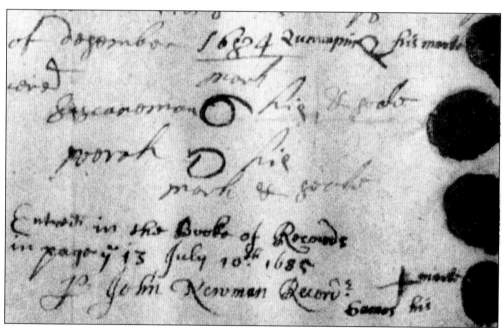

WERAH AND SUSCANNEMON'S MARKS. The Latting property deed bears the signature marks of the Matinecock chiefs, Werah and Suscannemon, who relinquished their lands to the early colonists. Note that the spelling of the Indian names on the deed vary from the spellings in common usage today. (Courtesy of Eve Califano.)

PERCY LATTING, 1905. Nitor the dog jumps for a snack offered by his master Percy Latting. The Latting family home Werah and the delivery wagon from the Schwab bakery, located on Glen Street in the neighboring the town of Glen Cove, can be seen in the background.

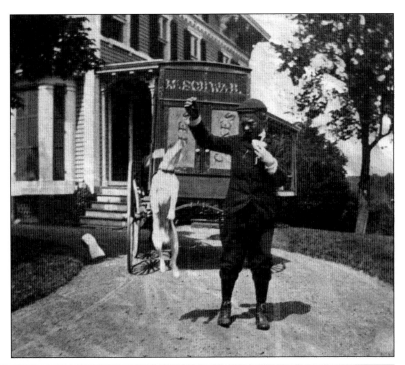

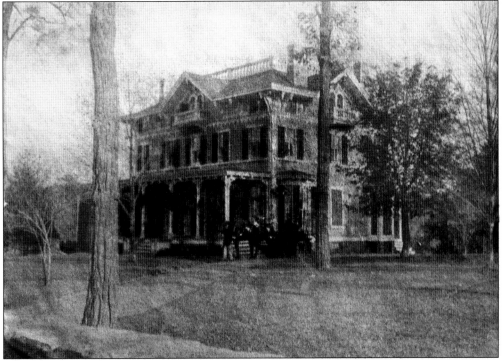

WERAH FARMS, 1905. The original Latting homestead, referred to as Rose Cottage, was moved to the opposite side of the property and forms a wing of the 1740 house. Although the appearance has changed slightly over time, this beautiful old home, a private residence, has kept its character with its ancient barn and fragments of the family cemetery on the grounds.

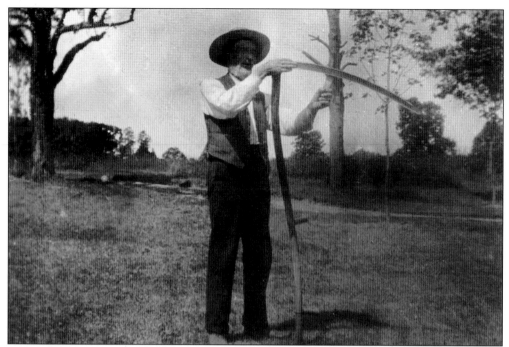

JAMES SOUTHARD, C. 1890. Seen here with his scythe, Southard was a prominent resident of old Lattingtown. Herbert W. Schierhorst, the current president of the Locust Valley Historical Society, is a descendant.

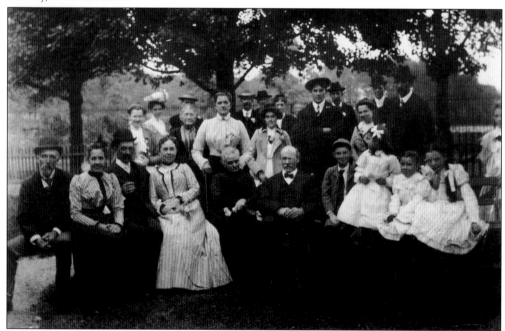

AFTER THE ASPARAGUS HARVEST. Matinecock, Lattingtown, and neighboring Bayville were heavily planted with asparagus. New crops were harvested from the mounded soil early in the morning and sent by wagon and train to New York markets. In celebration at the harvest party in the photograph are the Wilson and Bailey families with their neighbors.

UNION CHAPEL. In 1859, the first place of worship was built on Pudding Lane, now Lattingtown Road. Zebulon Wilson donated the land, and the Price family defrayed the cost of building the nondenominational chapel. When the chapel was razed in 1913, the bell was donated and the organ was appropriated by the new owners of the Price lands.

LATTINGTOWN, STREET VIEW. In this rare photograph of Lattingtown center before it was dismantled, the central gateway marks the entrance to the Guthrie estate Meudon, and the Union Chapel is visible on the right. In 1912, a new chapel was constructed around the corner under the auspices of St. Paul's Church of Glen Cove and became the independent Episcopal parish of St. John's of Lattingtown in 1915.

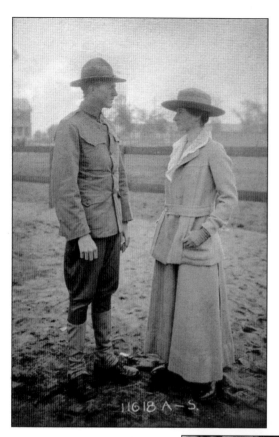

THE PENNOYERS. Frances Tracey Morgan, second daughter of financier J.P. Morgan Jr., married attorney Paul Geddes Pennoyer at St. John's of Lattingtown in 1918. Elaborate precautions were taken to make the small family wedding as private as possible. The Pennoyers resided and raised their family at Round Bush in Matinecock. (Courtesy of Paul and Cecily Pennoyer.)

ST. JOHN'S OF LATTINGTOWN, INTERIOR, 1923. The unique Clow Brothers English oak carvings and most of the stained-glass windows in St. John's were donated by J.P. Morgan Jr. The chapel was lengthened, and the entrance was moved to the southeast corner in 1923. It was expanded again in 1957 with the addition of side aisles and arches, and in 2002, a contemplative cloister and new wing were added.

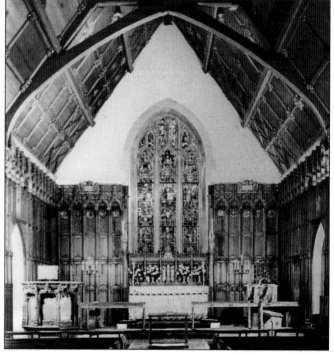

PRINCESS MARGARET AT ST. JOHN'S OF LATTINGTOWN, 1965. The Reverend Howard Lowell and the Reverend Rush Sloane greet H.R.H. Princess Margaret and her husband, Antony Armstrong-Jones, Earl of Snowdon, as they attend church at St. John's of Lattingtown. The offertory song "The Lord is My Shepherd" was selected because it was played at Princess Margaret's wedding. Throngs of people lined the road eager to see the royal couple.

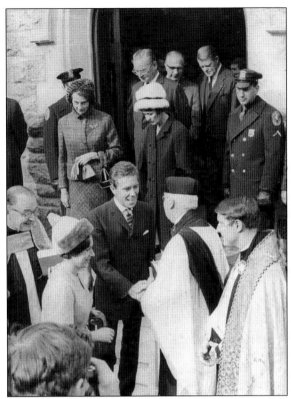

ST. JOHN'S COUNTRY FAIR, PEACOCK POINT. St. John's Country Fair was originally held on the grounds of the Davison estate at Peacock Point. The fair, an annual community event, features attic treasures, a silent auction, a book sale, and games for children. The 60th anniversary of the fair, now held on the church grounds, will be celebrated in 2012.

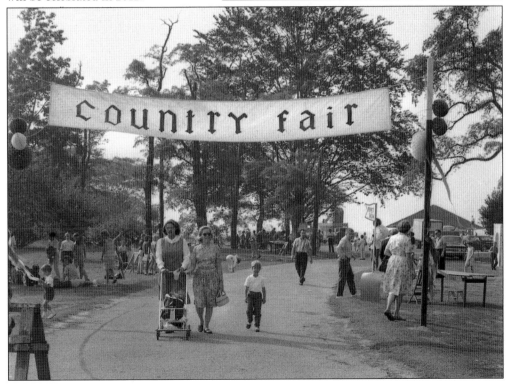

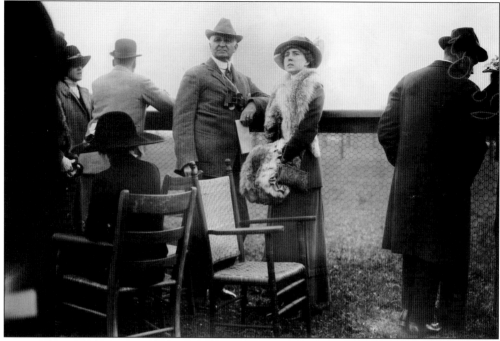

PAUL CRAVATH AND HIS DAUGHTER, VERA, 1913. Paul Drennan Cravath, the son of a Congregational minister from Ohio, founded the law firm that became Cravath, Swain & Moore. The law firm, still in operation, is among the oldest and most prestigious in the country. Cravath is seen here with his only daughter, Vera, an expert horsewoman, for whom the family's estate Veraton was named. (Courtesy Library of Congress.)

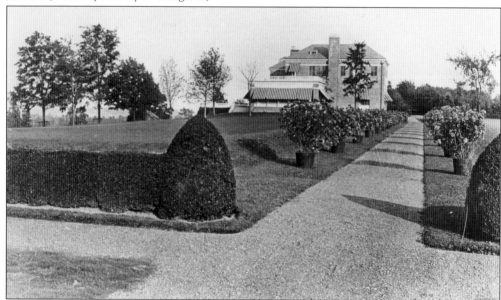

VERATON, 1905. Prominent attorney Paul Drennan Cravath bought the Frost family farm and built his English-style country estate there in 1905. After a fire destroyed the shingle Babb, Cook & Welch house, Cravath had a brick mansion built on the Lattingtown hilltop. When that burned, he sold the property for the development of The Creek Club, which opened in 1923.

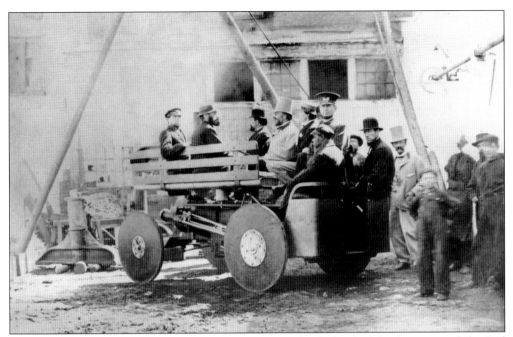

DUDGEON STEAM CAR. Richard Dudgeon, inventor of the hydraulic lift, also patented the Red Devil, the earliest self-propelled road vehicle. It ran without rails and proved a menace on New York City roads. Dudgeon frequently drove it at his Peacock Point estate and through the lanes around Lattingtown. A man on a horse waving a red flag preceded it.

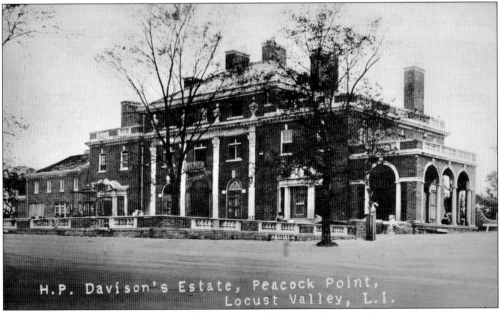

PEACOCK POINT. In the summer of 1916, when F. Trubee Davison developed an interest in aviation as a response to the war raging in Europe, H.P. Davison and his wife, Kate Trubee, opened their Peacock Point home to 11 of their son's Yale classmates as they trained as pilots and developed the First Yale Unit, the first naval aviation unit in the country. (Courtesy Collection of Paul J. Mateyunas.)

MR. AND MRS. JOHN E. ALDRED (JANE), 1914. Hydroelectric pioneer and utilities magnate John E. Aldred was a self-made man who spared no expense in the creation of Ormston, his magnificent 119-acre estate. Together with neighbor William D. Guthrie, he reportedly purchased the village of Lattingtown and had it razed to ensure the view he wanted at the entrance to his baronial property. (Courtesy of Library of Congress.)

ORMSTON HOUSE. This Tudor Revival Bertram G. Goodhue mansion was finished in 1918 and furnished with purchases made on more than 30 European buying expeditions. Surrounded by 119 acres of Olmstead–designed gardens, the grey fieldstone edifice and grounds were tended by a staff of 60 including 35 gardeners, 15 house servants, and assorted chauffeurs and handymen. In 1979, it was listed in the National Register of Historic Places.

The Lotowycz Sisters, 1960.
Sandy, Mary, and Ann Lotowycz, photographed by their sister Sophia, played in the gardens of Ormston as children. Their grandfather Wladimir Lotowycz, a married Ukrainian Catholic priest, helped arrange the purchase of Ormston House and the 119 acres of grounds from John Aldred in 1947 for the creation of St. Josaphat's Monastery. (Courtesy of Ann Lotowycz.)

St. Josaphat's Monastery. When utilities magnate John E. Aldred lost his fortune due to bad business investments in Mussolini's Italy, he forfeited Ormston. The grand showplace defaulted to the bank and was acquired by the Ukrainian Order of St. Basil for a contemplative retreat and training school for monks. (Courtesy of Jim Robertson.)

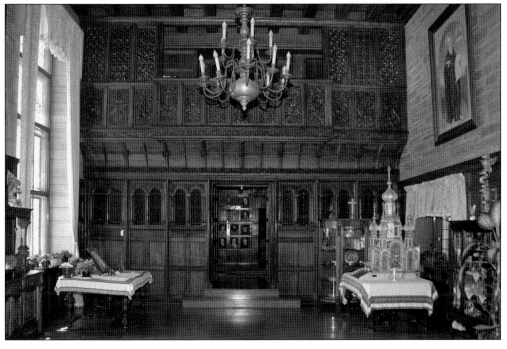

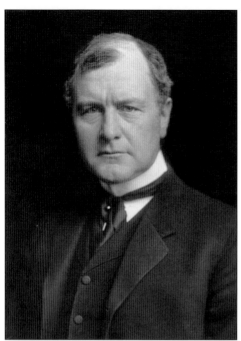

WILLIAM DAMERON GUTHRIE. Prominent orator and powerful constitutional lawyer William Dameron Guthrie was a Francophile. He had architect C.P.H. Gilbert design his country estate, Meudon, in the grand French tradition. Guthrie successfully carried out the fight against a federal income tax until 1913 and served as the first mayor of Lattingtown after it was incorporated in 1931. (Courtesy of Miani Johnson.)

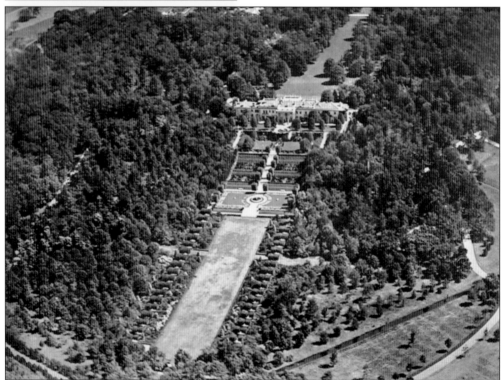

MEUDON. With its breathtaking view of Long Island Sound, the French Classical Revival mansion was surrounded by 300 acres of magnificent gardens that cascaded toward Long Island Sound in a series of terraces. Meudon was totally self-sustaining with its own farm group, dairy farm, bathing pavilion, greenhouse, and coal dock. (Courtesy of Edward Armstrong.)

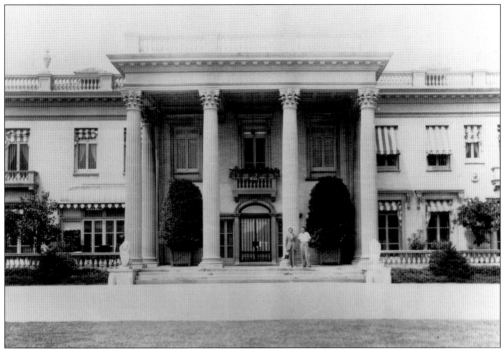

MEUDON MANSION. William Dameron Guthrie had his C.P.H. Gilbert mansion built in the image of Meudon, the home of Philippe, the younger brother of Louis XIV. In its last years, the white, 80-room mansion stood empty. It was razed in 1955 and buried along Frost Creek just west of the bridge to the bathing pavilion. (Courtesy of Edward Armstrong.)

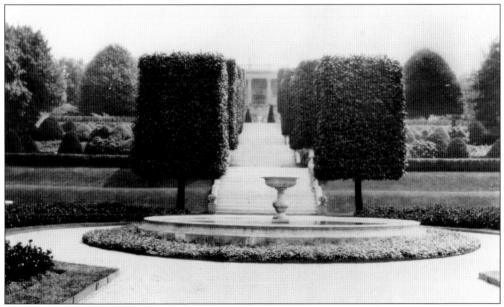

MEUDON GARDENS. The magnificent gardens at Meudon cascaded in a series of terraces on the north side of the mansion towards Long Island Sound. Designed by the Olmstead Brothers with Brinley and Holbrook, the gardens, horseshoe-shaped lawn, and grassy slopes were ornamented by sculpted vegetation, ornamental statuary, and architectural elements. (Courtesy of Edward Armstrong.)

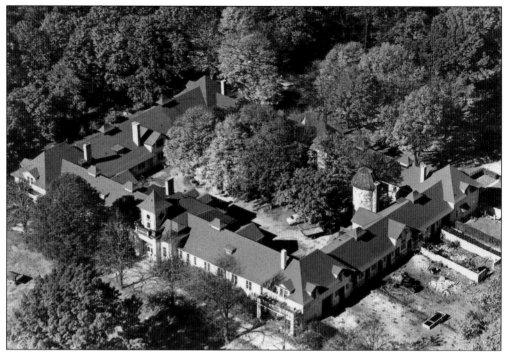

MEUDON FARM GROUP. Cows, sheep, pigs, and chickens lived in refined pastoral splendor on Meudon. This aerial view shows the animal barn located at the lower end of Peacock Lane. Ella Guthrie was known to drive about the estate in her electric car, making sure the property was maintained to her exacting standards. Workers found smoking were summarily dismissed. (Courtesy of Edward Armstrong.)

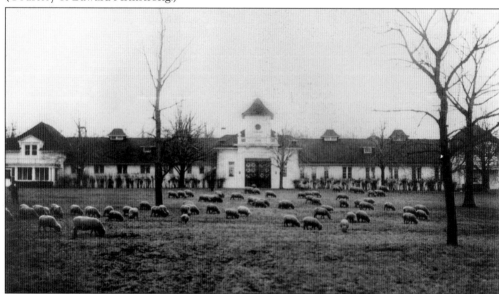

GUTHRIE'S BARN, 1905. Considered to be the largest and most beautiful structure of its kind on Long Island, the barn building on Peacock Lane, designed by C.P.H Gilbert, was constructed in 1902. It was built in the form of a square with a center stable yard. The complex had its own well and slaughterhouse. (Courtesy of Edward Armstrong.)

ARMSTRONG FARMS, 1956. In 1939, Frank Armstrong, an immigrant from County Fermanagh, Ireland, rented Meudon Farm Group from the Guthrie family and bought seven Jersey cows to establish his own dairy. He subsequently purchased the property and increased the herd to 130 cows. In this photograph taken a year after a major fire in the barn hayloft, Armstrong is seen feeding a calf. (Courtesy of Edward Armstrong.)

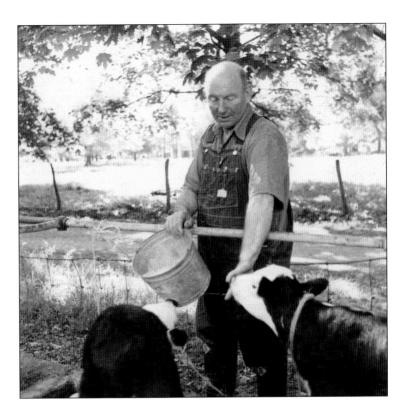

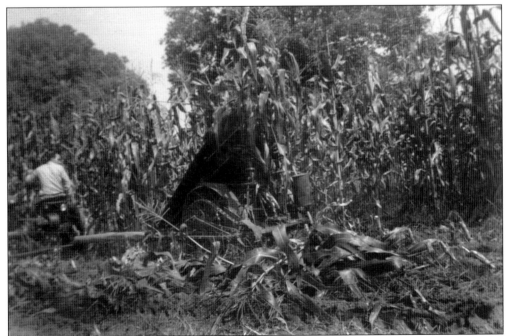

CUTTING CORN. Arthur Armstrong operates the corn cutter as he gathers feed for the family's dairy herd of Jersey cows. It took three cornfields to keep the herd in feed—one on Meudon, a second where Ayers Road is today, and another in Brookville. (Courtesy of Edward Armstrong.)

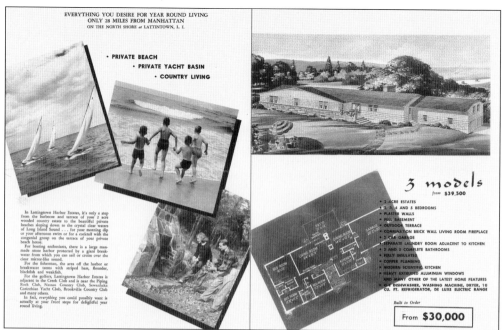

Lattingtown Harbor Estates, 1955. Shortly after World War II, Meudon was sold with the provision Ella Guthrie could live there for the remainder of her life. In 1955, the mansion was demolished and buried along the creek. Lattingtown Harbor Development Corporation, Inc., subdivided the property and built fine, individualized homes, while retaining the rustic beauty of the natural landscape. (Courtesy of Susan Hillberg.)

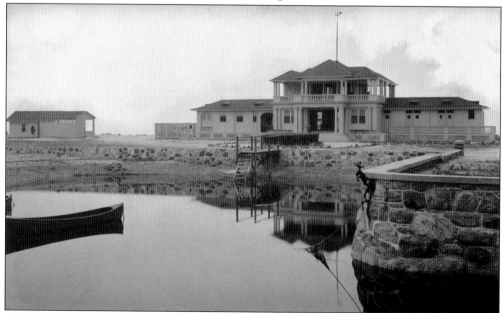

Meudon, Bathing Pavilion. Meudon's bath and boathouse survived the demise of the main estate as it was renovated and retained for the use of residents of Lattingtown Harbor Estates. The structure burned to the ground in a 1994 fire but was replaced using the original plans. It remains the center of summer social life in the community. (Courtesy of Miani Johnson.)

50

Four

LOCUST VALLEY

In 1869, the Long Island Rail Road was extended east to Locust Valley, and a depot was built a half-mile west of the crossroads at Buckram. Local lore contends that the extension was contingent on Buckram being renamed. Although this tale cannot be substantiated, it is known that Locust Valley was named for the Locust trees that forested the area; however, it is widely acknowledged that the change was not popular with Buckram old-timers.

The advent of the railroad was a pivotal point in Locust Valley history. The railroad transported local asparagus crops and canned produce to New York markets. Walton P. Davis, now a moving and storage company, did a lucrative business renting horses and buggies to arrivals on holiday from New York. Visitors often stayed at the nearby Depot Hotel, and the shopping district established at Locust Valley was sometimes referred to as "the Depot."

The economic boom in the late 19th century created newly minted tycoons who bought up Colonial farms and built palatial weekend and summer estates. The area became the nexus of the region known as "the Gold Coast." Local residents found employment on the estates. Although the influx of moneyed newcomers gave rise to an upstairs-downstairs situation, it also created a mutually symbiotic community with a shared heritage and appreciation for the land, which exists to this day.

By the 1920s, the ever-growing population had its own school, water district, and mail delivery. Housing was built along Forest Avenue and Bayville Road. Soon, the community had a need for its own bank. In 1923, a group of men led by Winslow S. Pierce decided to start a branch of the Glen Cove Bank in Locust Valley. Although the branch could not be established, financial arrangements were made, and the new Matinecock Bank opened for business in 1924. By the 1930s, the bank had its own brick building on Forest Avenue designed by noted local architect Bradley Delehanty. The hamlet of Locust Valley was firmly established as the official business district and town center of the region.

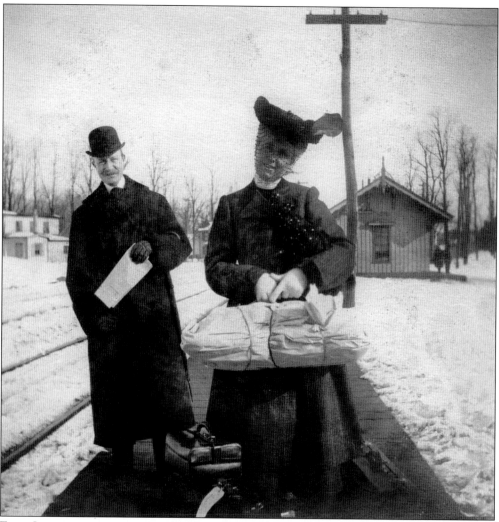

ELLA GUTHRIE AT LOCUST VALLEY DEPOT, C. 1910. The Long Island Rail Road was the main transport to New York City and beyond in the early days of the community. Ella Guthrie would have arrived at the station by horse-drawn sleigh on this snowy day at the beginning of the 20th century. (Courtesy of Miani Johnson.)

LOCUST VALLEY CANNING CO., 1890.
"From vine to can in the shortest possible time we can" was the slogan of the Locust Valley Canning Company's Pointer Brand. The cannery was located southwest of the depot near Nassau Country Club and canned peas, tomatoes, and other local crops. The first area cannery, which canned asparagus, was established in Dosoris.

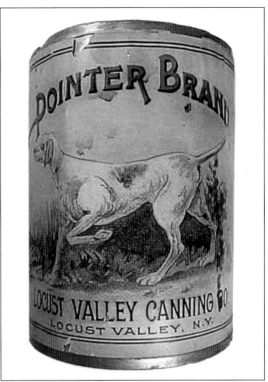

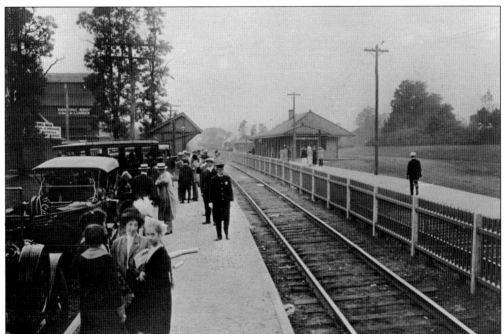

THE LUMBERYARD. The lumberyard established by Halsey M. Smith, and later owned by the Downing brothers, can be seen on the south side of the tracks. In 1927, facing difficult economic times, a group of independent lumber dealers incorporated into the unified Nassau Suffolk Lumber and Supply Company to meet the building needs of communities all over Long Island.

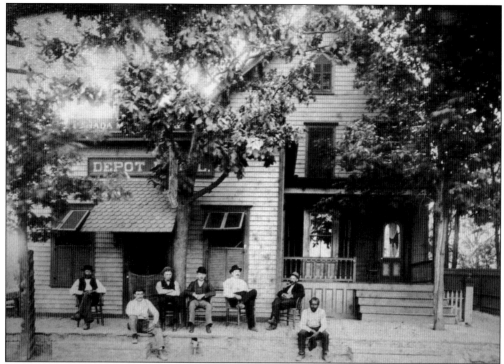

DEPOT HOTEL, C. 1890. Pictured from left to right are Thomas Labertson, Harvey Hall, William Monahan, Frank Fleming, William H. "Barney" Burnett, Herb Southard, and John Harvey Davis passing time in front of the Depot Hotel by the train station. (Courtesy of Townsend W. Cardinale.)

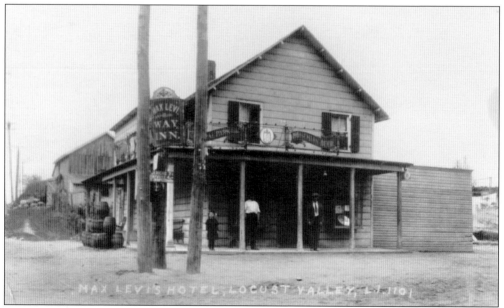

WAY INN. Max Levi's Way Inn, originally called Dobbers, was just one of the half-dozen saloons in old Buckram. Others included Barney's Corner, Reinhardt's (located by the garage near the railroad tracks), and the Stage Coach Inn.

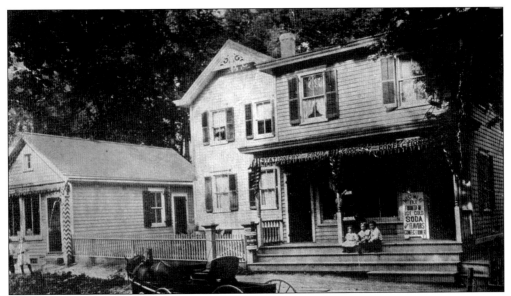

HENRY VAN WAGNER'S STORE. This old emporium on Birch Hill Road, fashioned out of an even older house, sold stationery, groceries, and confections as well as offered a fully operational soda fountain. The building remains in business today as an antique store.

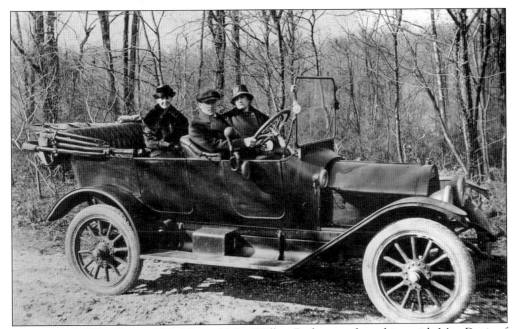

THE BAILEY'S NEW CAR, 1926. Mr. and Mrs. Wilbur Bailey, out for a drive with Mrs. Davis of Bayville, pause as photographer Mr. Decker snaps a picture of them in their new car. Bailey ran a taxi service for Piping Rock Club and lived on Underhill Avenue. The new automobile was reportedly the first of its kind in the area. (Courtesy of Wilbur Bailey.)

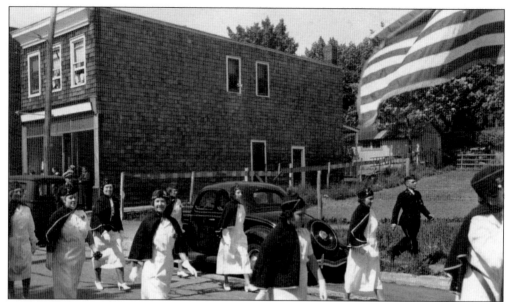

NURSES MEMORIAL DAY, 1930. A spirited group of nurses in uniform march on Birch Hill Road. Locust Valley was involved in the Red Cross from the time H.P. Davison served as chairman of the Red Cross War Council in World War I. In 1917, the Nassau Chapter was chartered under Kate Davison.

MATINECOCK MOTOR WORKS, 1928. The Motor Works, located on Forest Avenue, was built in the 1920s as a garage and gas station that sold Tydol gasoline. Owner Earl Widigen (kneeling at the left of the fender) later partnered with Allan Luyster (kneeling right) to run the business. The garage became a Dodge/DeSoto dealership but later returned to its roots as an automotive repair shop. (Courtesy of David Molloy.)

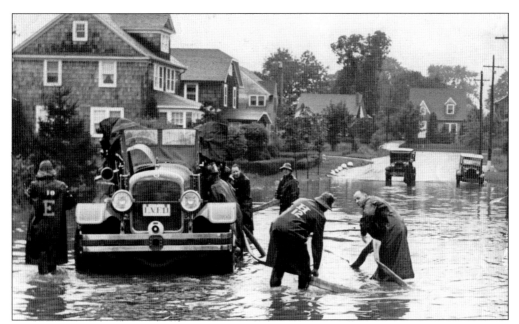

AFTER THE HURRICANE, 1938. The Locust Valley Fire Department pumps out West Sixth Street in the aftermath of the 1938 Hurricane that resulted in large amount of damage and loss of life on Long Island. (Courtesy of Locust Valley Fire Department.)

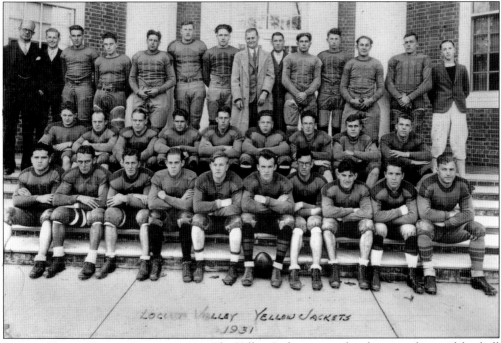

LOCUST VALLEY YELLOW JACKETS, 1931. The Yellow Jackets were a local semiprofessional football team initially sponsored by Judge Benjamin Downing and then by the Locust Valley Fire Department. The leatherheads were extremely popular with the community, which avidly followed the team. In its first six years, the team won 50 games, lost 6, and enjoyed a three-year-long undefeated winning streak. (Courtesy of Sam Bozzello.)

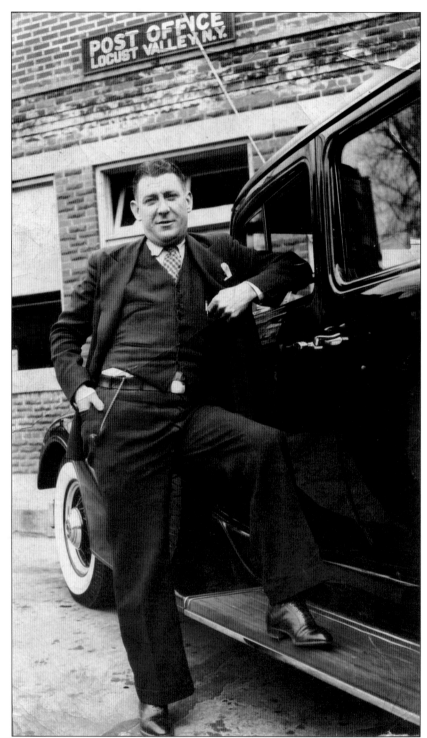

Postmaster Dudley C. Merritt, 1935. Pres. Franklin D. Roosevelt appointed Dudley C. Merritt postmaster of Locust Valley in 1934. Merritt served the town in that capacity until the late 1960s. He also acted for a time as manager of the successful Yellow Jackets football team.

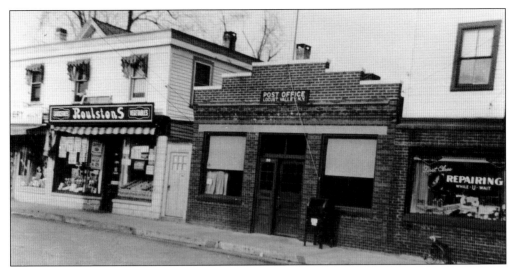

POST OFFICE BLOCK. The post office was located in different places through the years. Seen here on Birch Hill Road, the building later became the well-remembered Superette. The first mail service was by horseback from New York. Village delivery went into effect on April 1, 1941, with two carriers, and the post office achieved a first-class rating in 1948 by doing in excess of $40,000 business in a year.

GOSS CHILDREN. Postmaster Robert H. Goss and his wife, Margaret, had nine children. They are, from left to right, Peter, Anne, Alice, Paul, Sue, John Robert, Martha, Hattie, and Violet. Robert H. Goss was postmaster in 1920 and 1921, and Violet A. Goss was acting postmistress from 1921 to 1934.

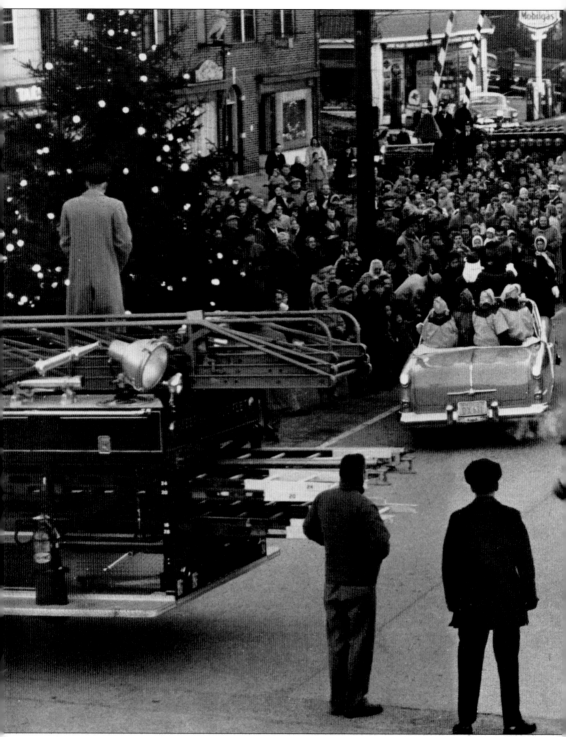

CHRISTMAS, LOCUST VALLEY, 1950s. Locust Valley gathers for the annual Christmas tree lighting at the intersection of Forest Avenue and Birch Hill Road, complete with Santa arriving in a convertible. William Britton of Britton's Hardware led the caroling. Today, the tree lighting

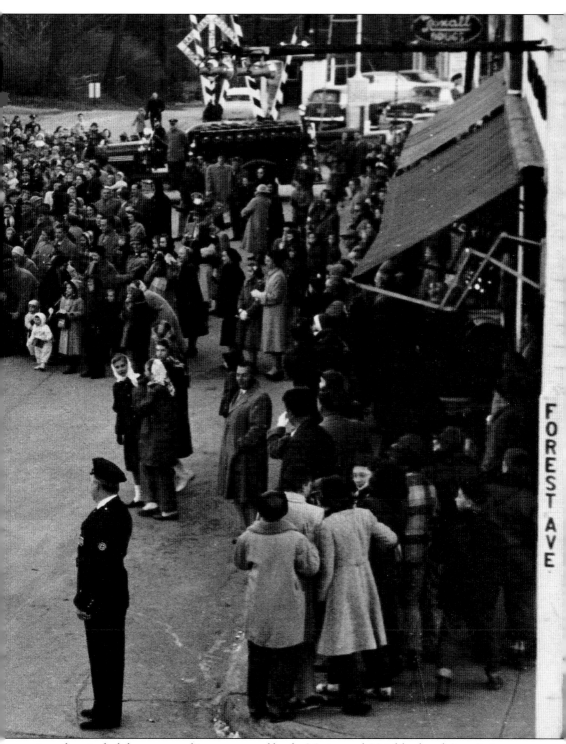

remains a favorite holiday event and is cosponsored by the Matinecock Neighborhood Association and the Locust Valley Chamber of Commerce.

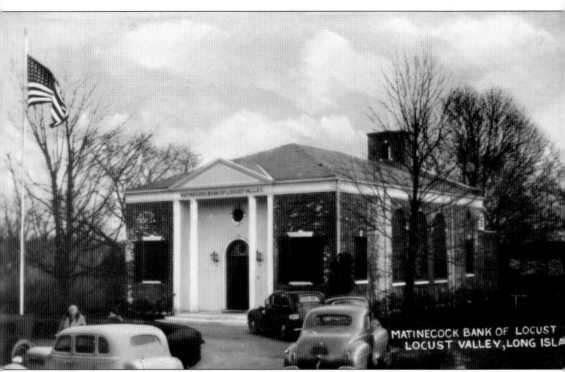

MATINECOCK BANK OF LOCUST
LOCUST VALLEY, LONG ISLA

MATINECOCK BANK. The Matinecock Bank was established in 1923 and facilitated by a $60,000 stock dividend from Glen Cove Bank. Davison, Downing, Gay, Payne, Pierce, Hodenpyl, Johnson, Seaman, Valentine, and Willit were the names listed as the bank's first directors. By the 1960s, the bank grew to include two branches in Bayville. The bank later moved to a brick Bradley Delehanty building on Forest Avenue, where it continued to service all members of the community. In 1924, the bank approved an application from the Dutch Reformed Church for a loan of $5,500 to build a parsonage on Midway Avenue, an area thus referred to as "Holy City."

MATINECOCK BANK VAULT.
The Matinecock Bank, the
economic mainstay of the
community, was noted for
its personalized service.
Credit was made available
and loans accorded
trustworthy customers on a
promise and a handshake.

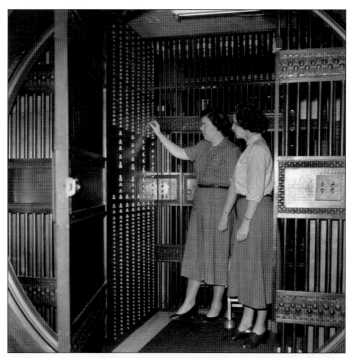

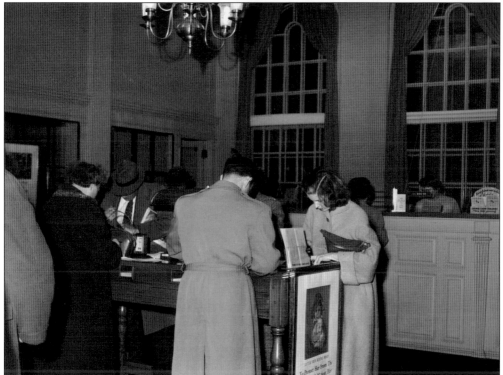

INSIDE MATINECOCK BANK. Loyal customers tend to their banking needs on a dark winter day
at Matinecock Bank. The bank, under the direction of Winslow S. Pierce, was a neighborhood
institution for many years.

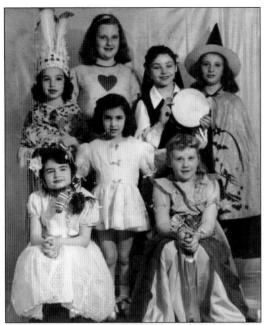

WINNIE MORLEY'S DANCING CLASS, 1945. Winnie Morley had the first class of her dancing school on Birch Hill Road commemorated in this photograph by George J. Gould. Dancers included Faith Morley, Carol Allgaier, Peggy Gallagher, the Festa sisters, M. Cirello, and JoAnn Castelluccio.

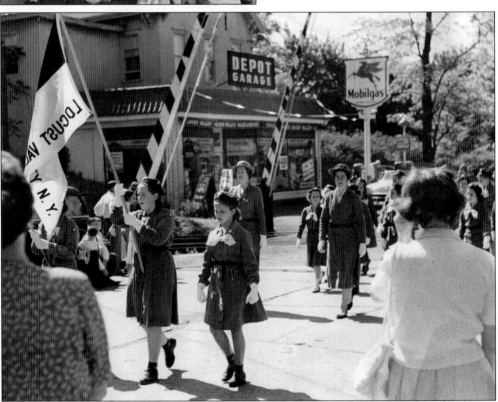

GIRL SCOUTS, 1955. Girl Scout leader Betty Lotowycz, center, marches with her troop past the Depot Garage on Birch Hill Road during the Memorial Day parade. The Locust Valley Girl Scouts were organized in 1926 under the leadership of Grace Downing. There were 25 girls in the first troop. By 1950, there were eight troops and over 115 girls involved. (Courtesy of Ann Lotowycz.)

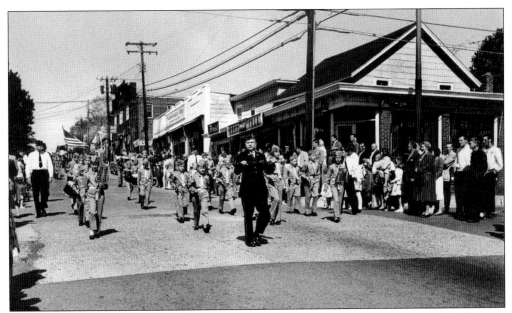

SONS OF THE AMERICAN LEGION BAND, 1962. The crowd watches as the drum and bugle corps marches in the Memorial Day parade down Forest Avenue towards the Birch Hill Road intersection in the heart of Locust Valley. The drum and bugle corps, established by American Legion member Tom Sarver, traditionally marched in the Memorial Day parades in Locust Valley, Glen Cove, and Bayville. (Courtesy of George Shaddock.)

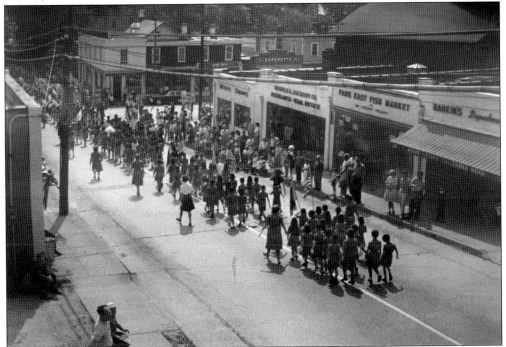

PARADE, FOREST AVENUE. On Memorial Day, the scouts are seen marching east on Forest Avenue toward Birch Hill Road, past Rabkin's Department Store, Park East Fish Market, Harold A. Jackson Co. Insurance-Real Estate, and Dupre's Liquor Store.

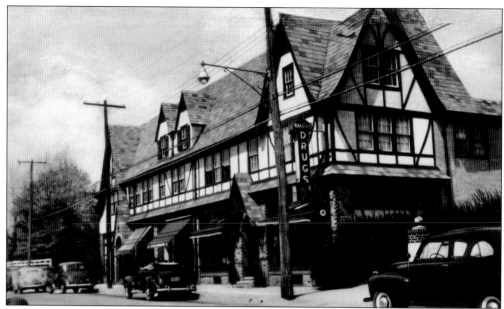

LIPPERT BUILDING, 1944. In 1928, Joseph and Anna Eleanora Lippert, a young immigrant couple, borrowed money from the Matinecock Bank to build the Tudor building on the corner of Ash Street and Forest Avenue to house their successful interior decorating business. They worked long hours to support their growing family and lived above the large first-floor shop and furniture showroom.

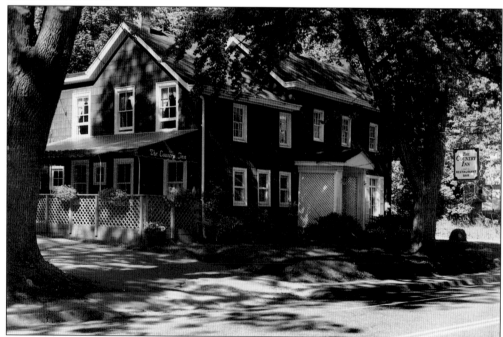

COUNTRY INN. Community residents were up in arms when old Buckram was threatened by development at the turn of the 21st century. The Country Inn, a bar and restaurant dating back to the early 19th century, was razed in the spring of 2001. Other buildings such as the Weeks House, built around 1690, are now landmarked and preserved.

CAMINARI'S. Freddie Caminari's popular town restaurant on the corner of Birch Hill Road was the site of the earlier Weeks Hotel owned by Edward A. Weeks. It stood opposite Levi's Saloon, which was called the Way Inn during the old Buckram era. Caminari's fed and housed actors from the city that were in town to appear in summer stock at the Red Barn Theatre.

BOOK ENDS, INC. With its entrance around the corner on Lindbergh Street, Book Ends, Inc., was located in an old house on Birch Hill Road and sold assorted gifts, toys, china, lamps, linens, and gadgets, as well as books.

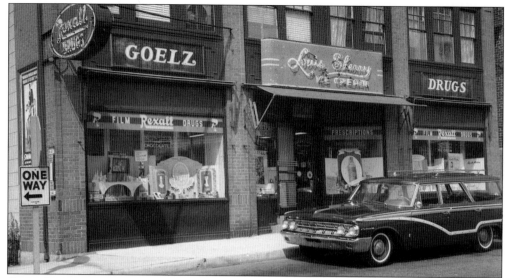

GOELZ PHARMACY. Founded in 1918, Goelz Pharmacy was a popular place for the actors at the nearby Red Barn Theatre to stop for a sandwich and soda. In the 1950s, proprietor Paul Stein carried Long Island's most complete line of exclusive perfumes and cosmetics. The store, located just to the northwest of the Birch Hill Road Railroad crossing, also sold toys, greeting cards, and ice cream. (Courtesy of Dean Mihaltses.)

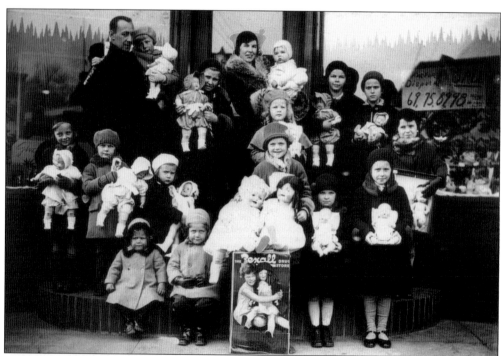

CHRISTMAS DOLLS. Goelz Chemists once belonged to the Rexall Pharmacy network purchasing and branding group. Every Christmas, they sponsored a promotional contest with a doll giveaway. Each participant received a doll and posed for a group photograph in front of the store. (Courtesy of Dean Mihaltses.)

BIRCH HILL ROAD STORES, 1950. Phelan's took care of the town's appliance needs, Stein's sold stationery, and Dupre's provided libations. Canadian Edouard Dupre brought liquor into the United States from Canada during Prohibition in a secret compartment in his very large car. Later, his liquor store legally served the town from its location on the corner of Birch Hill Road and Forest Avenue.

GIVENCHY AND POSH. Gradually, the saloons, dry goods stores, and Superette gave way to antique emporiums, chic clothing stores, and elegant designer boutiques. Birch Hill Road and the Plaza Shoppes, built in the early 1970s, became a destination for shoppers with discerning tastes.

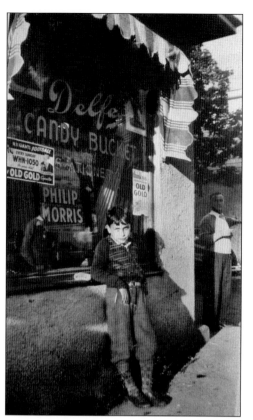

DELFE CANDY BUCKET. Ralph Bruschini enjoys a visit to Papsidero's corner candy store on Forest Avenue in the Forest Park section of town with his father, Angelo "Charlie" Bruschini. An immigrant from Italy, Angelo worked on the Arthur Vining Davis estate during World War II. (Courtesy of Carol Kenary.)

FARRELL HOUSE. In the 1920s, the Farrell property was seen as a pioneer homestead because the other homes on West Fourth Street had not yet been built. Oonto Smith, a descendant of Captain Underhill, first owned the property. Joseph and Mary Farrell and an unidentified man enjoy the property, which included a large vegetable garden.

Five

COMMUNITY

Residents of Locust Valley, Lattingtown, and Matinecock, both wealthy and less prosperous, were forced by geographic isolation to band together and solve local problems like poor roads, lack of a nearby hospital, and the need for mosquito control. In 1907, the community, led by Frank Nelson Doubleday and F. Coit Johnson, formed the Feeks Lane Association to repair a rutted country road. Recognizing a need for further area improvements, the group formally reorganized into the Matinecock Neighborhood Association (MNA) in 1908 and built the Matinecock Neighborhood House on Buckram Road, now the Locust Valley Library.

The Matinecock Neighborhood Association revitalized the Locust Valley Reformed Church under the leadership of Rev. E. Fred Eastman, who served as both pastor and secretary of the MNA. Together, they established a health and relief committee and a craft guild. Today, the association, still a strong presence, funds community improvements like the Scout Hut, the World War I cannon memorial at the library, and the Friends Meeting House Triangle.

The community volunteer fire department, formed in 1893, joined the MNA in 1914 to become the official Locust Valley Fire Department, with Frank N. Doubleday as chairman of the board. The department headquarters was in the Neighborhood House with the fire engines housed in the lower level, now the library community room. The Neighborhood House and grounds, which included two tennis courts and an indoor bowling alley, were wholly given over to the library in 1935. As Locust Valley is an unincorporated hamlet, the association library today functions as a de facto community center and meeting hall for both Locust Valley and the larger community.

Post–World War II Locust Valley, though transformed into an upper–middle class bedroom community, retained its special sense of civic pride and responsibility marked by the formation of Operation Democracy, the Grenville Baker Boys and Girls Club, and the stalwart presence of American Legion Howard Van Wagner Post 962.

FRANK NELSON DOUBLEDAY. The great publisher Frank Nelson Doubleday, nicknamed "Effendi" by Rudyard Kipling (a play on his initials meaning "master" in Arabic), was a guiding force in the formation of Locust Valley. He was a founding member of the Matinecock Neighborhood Association and the library in partnership with his first wife, author and naturalist Neltje De Graff. (Courtesy of Locust Valley Library.)

F. COIT JOHNSON. 1923. F. Coit Johnson, a founder of Matinecock Neighborhood House and a stalwart member of the early community, is seen here with daughter-in-law Eunice Johnson and grandson Stuart at his home off Feeks Lane. Fish from the Johnson family pond were released into Beaver Lake and are reportedly the ancestors of the schools of large carp that populate it today. (Courtesy of Eunice Johnson Winslow.)

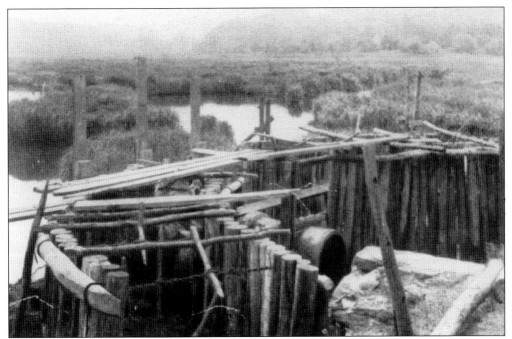

MILL NECK DAM. The Matinecock Neighborhood Association had a dam built at the foot of Feeks Lane, effectively filling in a malarial breeding ground and swampland and creating Beaver Lake. The dam divides freshwater Beaver Lake from the saltwater of Mill Neck Creek.

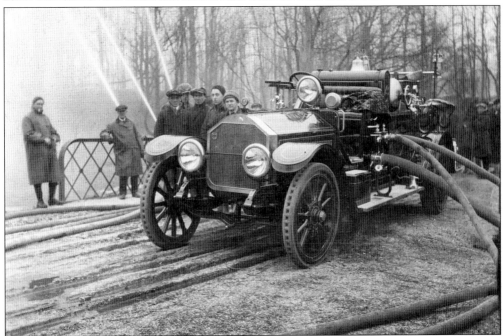

PUMP TEST, 1919. The Locust Valley Fire Department tests the pump on their new American La France on the causeway at Mill Neck Dam. The purchase of the LaFrance, a 750-gallon-per-minute pumper and chemical truck, was seen as a major step toward becoming a modern fire company. (Courtesy of Locust Valley Fire Department.)

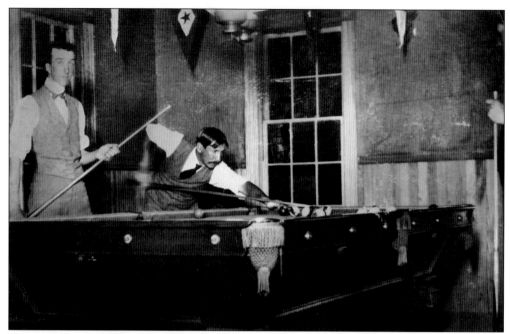

BURLING COCKS, 1910. Burling Cocks and his friend Ed Craft perfect a corner pocket shot. Cocks died a bachelor in May 1913 at his ancestral home on Duck Pond Road. He left generous bequests to the Locust Valley community, including Friends Academy and the Matinecock Friends. Burling Cocks Memorial Hall in the Neighborhood House, now the community room in the library, was named for him.

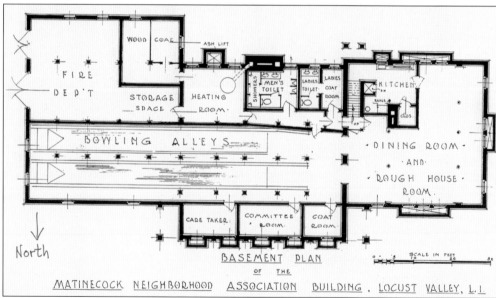

MATINECOCK NEIGHBORHOOD HOUSE, FLOOR PLAN. The Neighborhood House was built in 1914 with donations of money and labor from community members. The upper level had a 300-seat auditorium, and the lower level contained a bowling alley and firehouse. There were reading rooms, social rooms for pool, cards, and other games, informal meeting rooms, and a kitchen. A library wing was added in 1923.

LOUIS AND ADDIE ALLEN, 1908. The Allens, who lived at White Spots, donated their barn to serve as a community hall before the Neighborhood House was built. The barn was outfitted with a piano, gramophone, and pool table. Singing, dancing, and card playing were part of the general merriment at the early Matinecock Neighborhood Association gatherings.

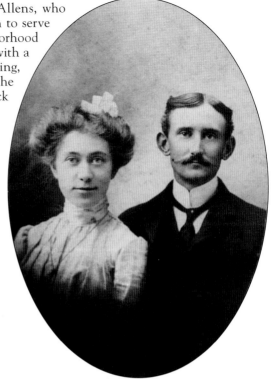

MATINECOCK NEIGHBORHOOD HOUSE. Originating from the 1908 civic group formed to grade Feeks Lane, the MNA is the oldest civic association in the area. It was created for "the purpose of awakening and keeping healthy the social side of village interests" during the transition from rural to suburban living. Cravath, Doubleday, Johnson, Hodenpyle, Downing, Wagner, and Eastman were among the surnames of the founding fathers.

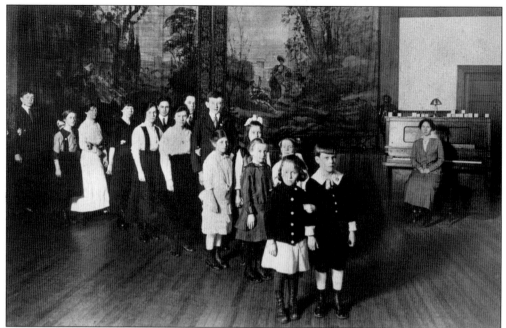

DANCING CLASS AT NEIGHBORHOOD HOUSE, 1917. Matinecock Neighborhood House became the center of the Locust Valley community, offering dance classes, theatrical events, reading rooms, and even the opportunity to bowl and play tennis. Today, the Matinecock Neighborhood Association is still going strong, and the Neighborhood House is home to the Locust Valley Library. (Courtesy of Linda Bruder.)

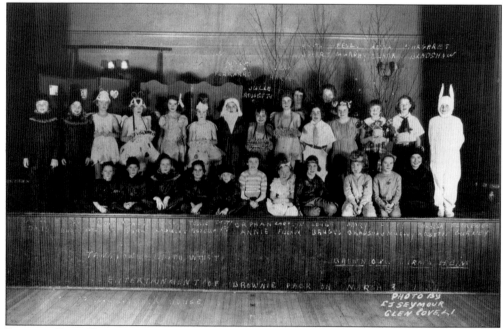

BROWNIE PACK ENTERTAINMENT, 1934. The 300-seat auditorium in Neighborhood House was specially designed to accommodate motion picture shows, art exhibitions, basketball games, plays, and costumed Scout troop entertainment, as pictured here.

THE FIRST LIBRARY, 1915–1921. The Locust Valley Library, formed in 1909 under the leadership of Frank N. Doubleday and Edward M. Ward, was granted a charter from the New York State Board of Regents on September 10, 1910. The library occupied the first floor of the 1865 Bailey house on Bayville Road. Young Nelson Doubleday's first printing press was housed behind it.

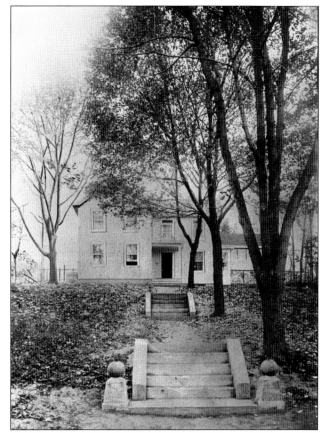

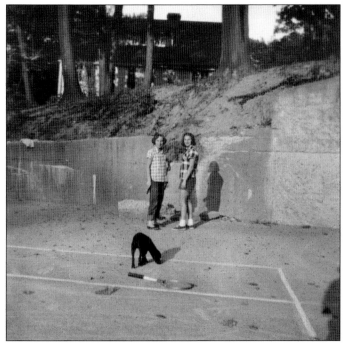

TENNIS COURTS, 1946. Janice Shaddock, left, and Irene Harubin take a break from their tennis match on the Locust Valley Library Tennis Courts. Shaddock's dog, Spar, seen in the foreground, is named for the US Coast Guard Women Reserve appellation Semper Paratus, translated in English as "Always Ready." (Courtesy of Janice Deegan.)

RED MARY, 1916. In 1912, Locust Valley Fire Department acquired a Mercedes Simplex that had been involved in an accident. George L. Klohs restored and refitted it for department use with a 500-gallon centrifugal pump. This unique vehicle is thought to have been the first motorized pumper in New York State. (Courtesy of Locust Valley Fire Department.)

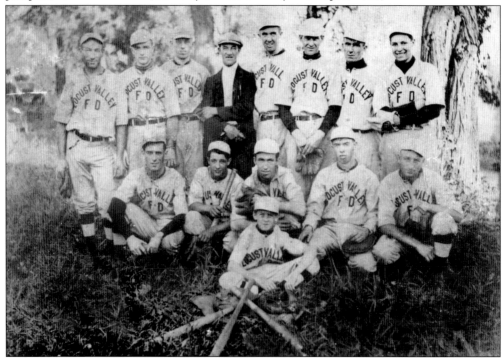

LOCUST VALLEY BASEBALL TEAM, 1917. In March 1920, the Locust Valley Fire Department voted to officially recognize its unofficial but very active baseball team as formally representing the department. The team, a local favorite, was the finest in the area for some time.

LOCUST VALLEY FIREHOUSE. The Locust Valley Firehouse, designed by Bradley Delehanty, was built in 1926 at the bend in Buckram Road on the site of a filled-in pond.

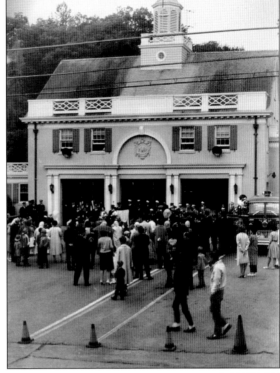

CLAM BAKE AT GUTHRIE'S, 1940. The estate owners and local country clubs have always been great supporters of the fire department and other local civic associations. In this picture, the members of the Locust Valley Fire Department enjoy a clambake on Meudon Beach at the Guthrie estate in Lattingtown. (Courtesy of Locust Valley Fire Department.)

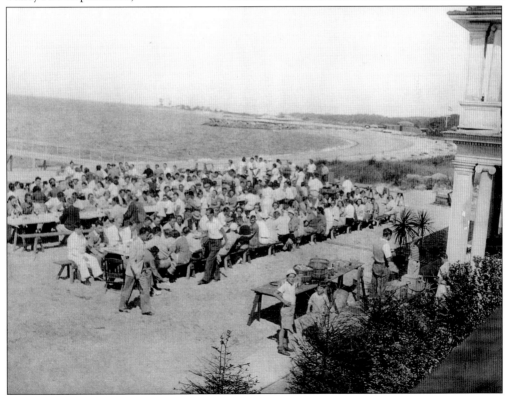

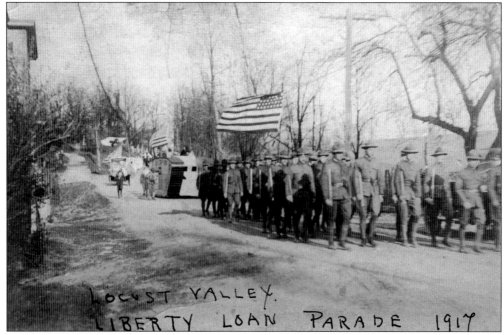

LIBERTY LOAN PARADE, 1917. The Liberty Loan parade during World War I was met with great patriotic enthusiasm in the Locust Valley community. Fueled by the example of Theodore Roosevelt and Woodrow Wilson, Liberty Bonds were bought as a point of civic pride and duty. (Courtesy of Linda Bruder.)

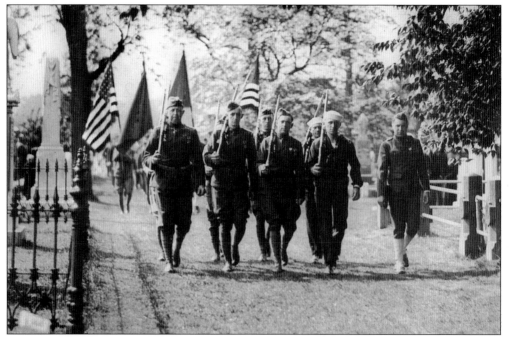

MEMORIAL DAY PARADE, 1930. Members of the American Legion who were veterans of World War I march through the Locust Valley Cemetery during the 1930 Memorial Day parade. From the left, the first man is John Carruthers and the fifth man is George Shaddock; others are unidentified.

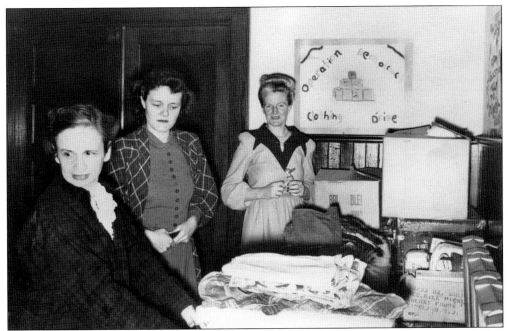

OPERATION DEMOCRACY, 1948. Post–World War II volunteers like (from left to right) Helen Karlen, Martha Breasted, and Hazel Greenfield garnered thousands of items of clothing to be sent to France. Inspired by the vision of Locust Valley's Lt. Col. Augustin S. Hart Jr. of the 82nd Airborne Division and Martha Breasted, Operation Democracy was formed. Locust Valley adopted Sainte Mere Eglise, the first town liberated during the invasion of Normandy, as its sister city.

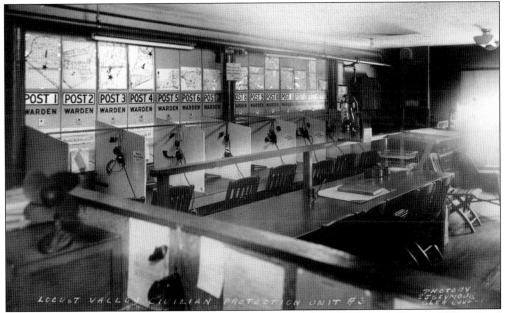

CIVIL DEFENSE, 1951. William E. Britton was the chief warden of defense for Locust Valley. Civil Protection Unit No. 3 was headquartered in the lower level of the library. This volunteer group organized in 1941 and worked in conjunction with the state police, state guard, and civil air patrol to protect the community against enemy air attacks.

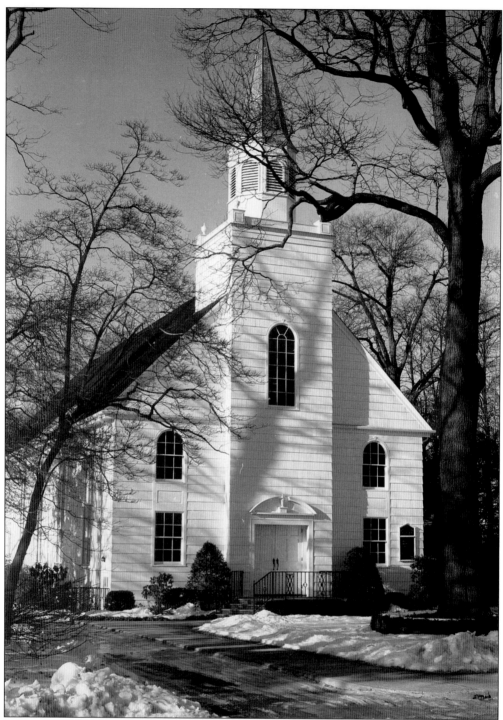

LOCUST VALLEY REFORMED CHURCH, 1962. Locust Valley Reformed Church was built on land purchased by Daniel V. Smith and was dedicated on July 4, 1869. Until 1871, it was an extension of the Brookville Reformed Church. Pastor Rev. E. Fred Eastman is remembered for his tract about Locust Valley called *Fear God in Your Own Village.*

LOCUST VALLEY CEMETERY, 1963. The cemetery adjoining the Reformed church was purchased for use as a nondenominational burying ground in 1868. The first person laid to rest there was Fanny Craft Morrell. The greater Locust Valley Cemetery, incorporated in 1917 and designed by Olmstead, was laid out like a woodland garden. It is one of the first park-like cemeteries in the country.

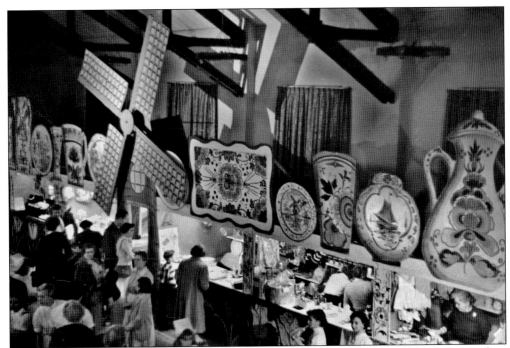

LOCUST VALLEY REFORMED CHURCH FAIR, 1956. In 1949, church membership was expanding rapidly with the growth of the suburbs. An Army chapel was purchased from Camp Davis in North Carolina, dismantled, and reassembled to serve as the parish hall. The annual country fair, a popular community event held in the hall, brought considerable income to the church.

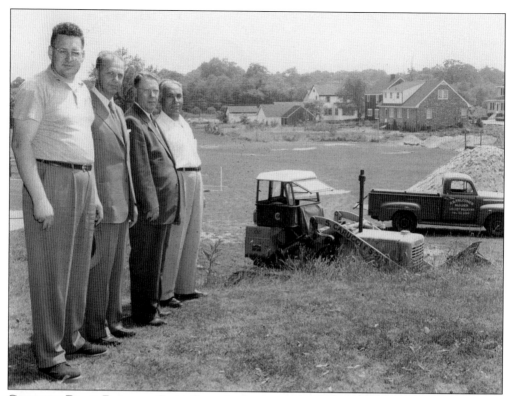

GRENVILLE BAKER BOYS AND GIRLS CLUB. In the top image, William Hinckley, far left, supervises the ground-breaking for the Grenville Baker Boys Club. In the bottom image, a trophy is held before the photograph of Grenville Baker. The club began as a teen football team and local adults, led by Edith Hay Wyckoff and Milward W. "Pidge" Martin, decided they should have a place to play. The Forest Avenue location and funds for the club were donated by Mrs. George F. Baker (Edith) and family in memory her son Grenville, a distinguished flier during World War II. Girls were invited to become club members in 1981. (Both, courtesy of the Grenville Baker Girls and Boys Club.)

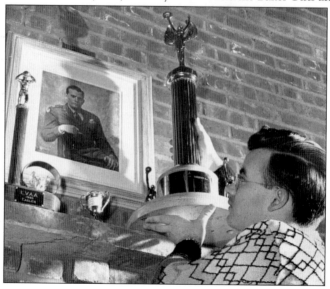

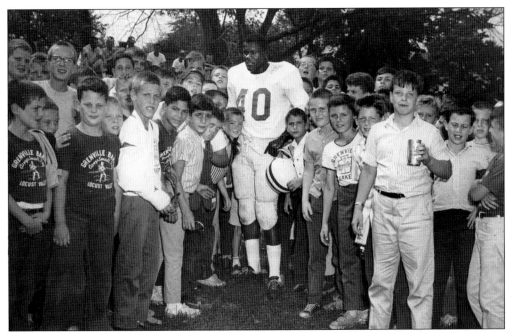

MATT SNELL, 1964. Famous New York Jets fullback Matt Snell grew up in Locust Valley. In the summer of 1964, the Grenville Baker Boys Club's Camp Small Fry visited him at the Jets summer training camp in Peekskill, New York. (Courtesy of the Grenville Baker Girls and Boys Club.)

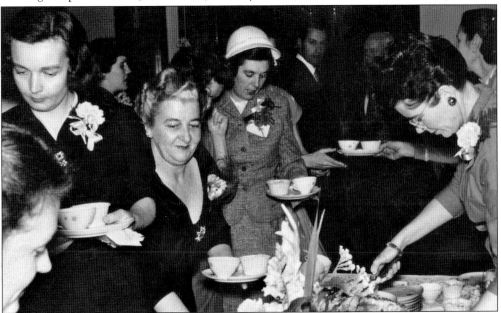

LOCUST VALLEY WOMEN'S CLUB, 1948. The Locust Valley Women's Club was formed in 1947 when five women coalesced like-minded friends to enlist in their civic cause. The club's philanthropic endeavors included food drives, scholarships, and assistance for those facing medical challenges. One year, the club successfully convinced Nassau-Suffolk Lumber to donate coal for a needy family rather than to purchase a journal advertisement. (Courtesy of Jacqueline Bartley.)

DE GRAFF CAUSEWAY. The De Graff Causeway is named for Robert De Graff, founder of Pocket Books, who spearheaded the fight to protect this fragile and rare grouping of wetlands from Robert Moses's plan to build a bridge across the sound. The North Shore Wildlife Sanctuary's Allsopp-Fisher Salt Marsh Preserve lines the two peninsulas north of the causeway.

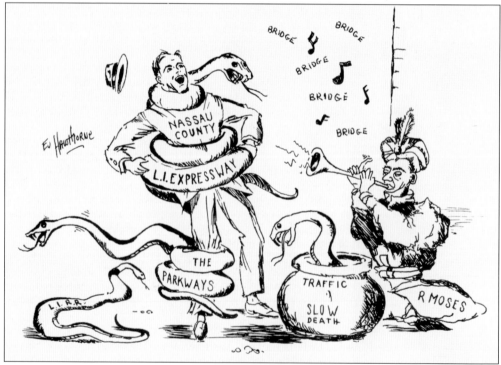

MOSES'S FOLLY. The *Locust Valley Leader* ran political cartoons as part of the community-wide effort of environmentalists and citizens to defeat Robert Moses plan to build the Oyster Bay-Rye Bridge. In June 1973, Gov. Nelson Rockefeller announced the defeat of the bridge, which would have destroyed the wetlands, killed wildlife, and forever altered the natural beauty of the North Shore.

Six

ACADEMIC LIFE

Education has always been of paramount importance to area residents. Locust Valley Central School District, which celebrated its 50th anniversary in 2010, is one of the most highly regarded districts on Long Island. Locust Valley is also home to two excellent private schools: Friends Academy and Portledge School.

Before the district was created, young scholars were home schooled or attended subscription school funded by donation. In 1841, Lot Cornelius founded the Walnut Grove Seminary in the Cock house in Matinecock. Richard Downing, Queens County treasurer, and Townsend Cock, president of Oyster Bay Bank, were graduates. In 1857, the school evolved into the Walnut Grove Female Seminary.

The first public schoolhouse in Locust Valley was a one-room frame building centrally located on the Wright farm by Ryefield Road. A two-room "School in the Woods" followed on the other side of the road. When it burned, the more substantial Belfry School was built around 1900. It was a two-story brick building with three classrooms, a small auditorium, and a belfry. In 1912, land between the school and the Methodist Episcopal church was graded to create a playground, and then property across the street was purchased for use as a playing field. In 1926, the old church was razed and a new intermediate school was built on the corner of Ryefield and Bayville Roads. Belfry School was in operation until it burned in 1962.

In 1960, the Locust Valley Central School District was formed with three elementary schools: Locust Valley, Bayville, and Brookville. Brookville School, located on Wolver Hollow Road, closed in 1978, and Locust Valley Primary School was renamed the Ann M. MacArthur School when its first principal retired in 1985. The central district opened its own high school in 1962 on Horse Hollow Road, so residents no longer had to commute to Oyster Bay, Glen Cove, or Carle Place for the last three years of high school. Administrative offices for Locust Valley were located at the Gables, an estate formerly owned by Lilla Brokaw Dugmore. When the old estate house burned in 1967, the current administration building was reconstructed on the site.

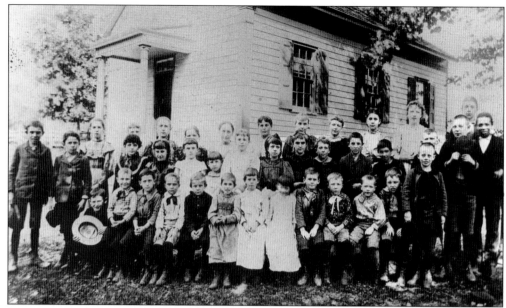

BROOKVILLE SCHOOL. The Brookville School, once part of the Locust Valley Central School District, closed due to shrinking enrollment in 1978. Ironically, the district was so crowded in the 1950s and 1960s that classes had to be held on the nearby estates Killibeg, located on Duck Pond Road, and at the Gables on Horse Hollow Road.

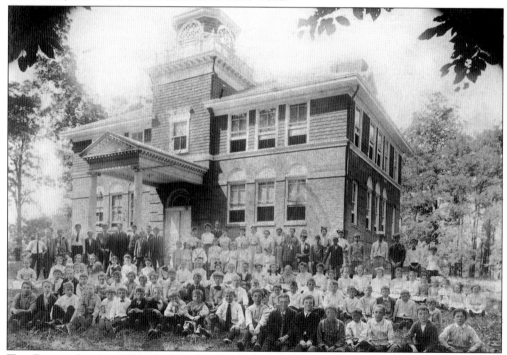

THE BELFRY SCHOOL. Shareholders built a basic school in 1801 that was soon outgrown. By 1848, the Cock family contributed $5,000 to build the first real school on land bought from Isaac Townsend for a nominal price. This school with a belfry was two stories high and had room for all the children of the district at that time.

Methodist Episcopal Church of Locust Valley, June 18, 1915. Gladys Van Wagner, left, and Florence Nelson stand before the Methodist Episcopal church that was located on present-day school property. This evangelical organization, dating from 1838, evolved into a nondenominational Christian church without a regular preacher. The congregation dwindled, and years after its closing, it was dismantled and a new school building took its place. (Courtesy of Linda Bruder.)

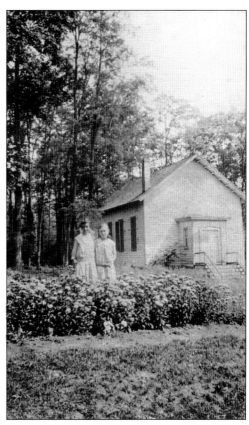

Locust Valley School, 1927. Coffin and Coffin were the architects of the new larger school. Jesse Mould, the principal from 1911 to 1937, strongly advocated the school's construction. During building, school board member F. Coit Johnson argued so strongly against part-time school sessions, temporary school space was established in town so all students could attend full-day classes. Mould's son Jesse Albert Mould was principal from 1958 to 1967.

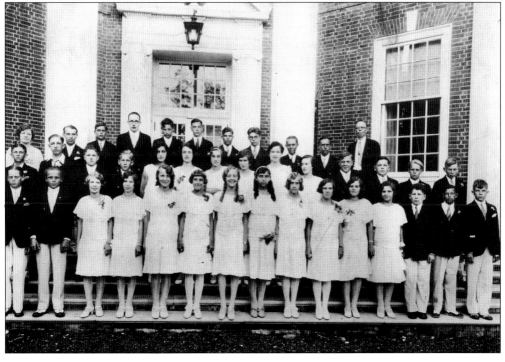

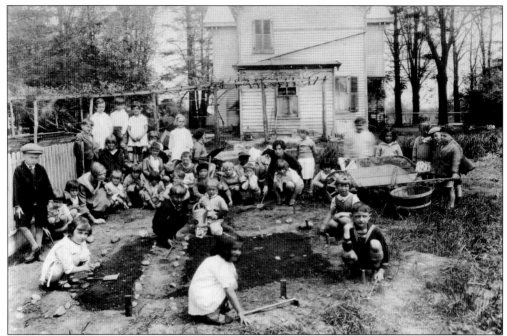

SCHOOL DAYS, 1920s. It is evident from these photographs that a holistic approach to education was taken in the early days of Locust Valley Schools. Students participated in gardening and creative crafts like basketry, toy-making, and woodworking, as well as traditional academics. In the image above, the kindergarten children participate in digging and sowing a garden, and below, principal Jesse Mould supervises a boys' hammock-making exercise. At that time, the setting of the school was essentially rural as it was located just opposite the active Wright Farm.

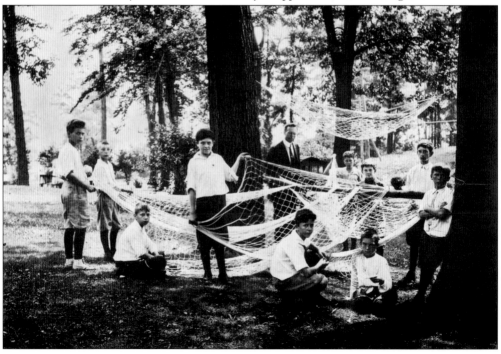

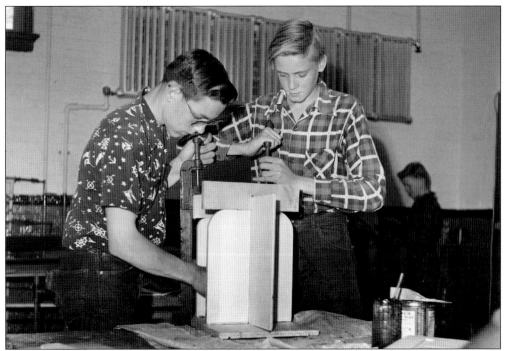

Locust Valley Shop Class, 1954. Locust Valley boys continued the tradition of woodworking in shop class. In the 1920s, the Matinecock Neighborhood Association financially supported a plan to assist the economically beleaguered area carpenters in making birdhouses and garden furniture. Although the plan was not a huge success, it was a testament to the resourcefulness and work ethic of the community.

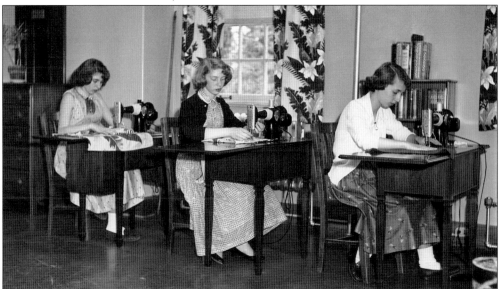

Locust Valley Home Economics, 1954. Home economics was a standard part of Locust Valley Junior High School curriculum. Young women learned to cook and sew. Some, like future junior prom queen Sherry Fox (pictured on page 96), even used their skills to make the dresses they wore to the festivities.

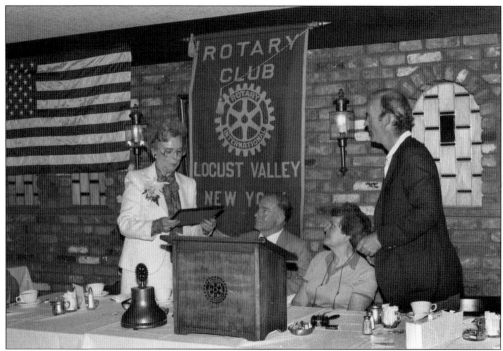

DR. ANN M. MACARTHUR, 1985. In this image, Dr. Ann M. MacArthur is being honored by the Locust Valley Rotary, which presented her with a proclamation recognizing 30 years of service to the district. From left to right are Dr. Ann M. MacArthur; Frank Armstrong; his wife, Elsie Armstrong; and rotary president Woody Millen. Dr. MacArthur was the first principal of the school when Locust Valley Central School District was formed, and the school was named for her after her retirement.

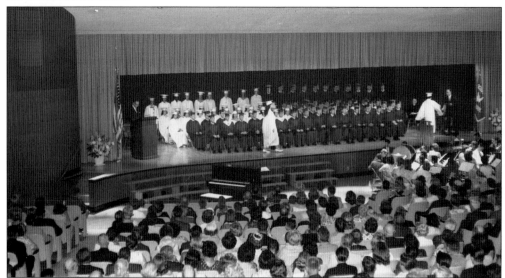

POMP AND CIRCUMSTANCE, 1963. The first graduating class of the Locust Valley High School marches proudly across the stage of the newly completed auditorium. The completion of the high school meant students no longer had to commute out of town for their last three years of schooling at either Glen Cove, Oyster Bay, or Carle Place.

Miss Stoddart's School for Very Little People Graduation. In 1933, Molly Stoddart established a school in Locust Valley for children 6 to 10 years of age. After her untimely death in 1953, the school carried on and was incorporated into the newly founded Portledge School in 1965. Headmistress Mary F. Johnson continued to guide the development of the Portledge Lower School.

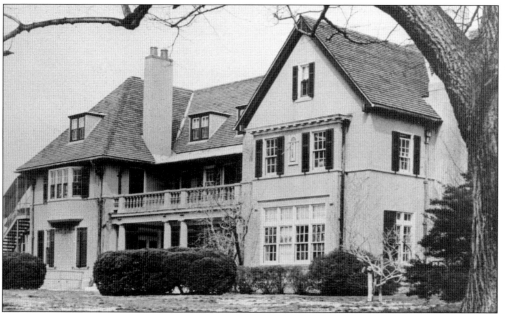

Portledge, 1910. This 63-acre estate designed by Howard Greenley for Charles Albert Coffin— founder, president, and chairman of the board of General Electric—became a coeducational college preparatory day school. Portledge School opened in September 1965 with 100 children enrolled from nursery to second grade. One grade a year was added until the first senior class graduated in 1976.

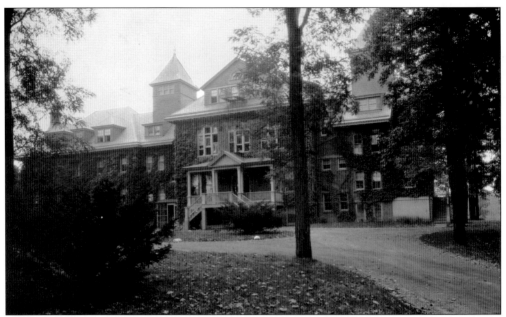

FRIENDS ACADEMY, 1900S. Friends Academy was founded in 1877 and built on land purchased from William T. Cock and located directly across from the Friends Meeting House. Tuition and board was $150 per year. Languages cost $10 extra per year and a flat fee of $8 per year was levied on upper-class students for advanced instruction. (Courtesy of Friends Academy Archive.)

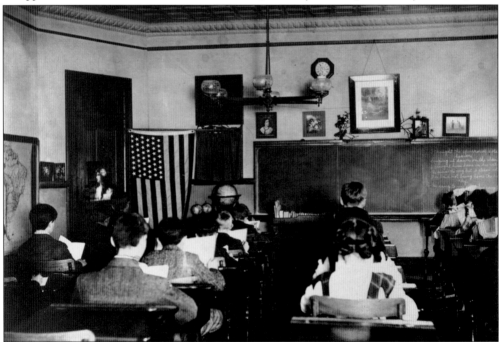

FRIENDS ACADEMY CLASSROOM, 1900S. The original Friends Academy building was sold in August 1896 to W. Burling Cocks, a trustee and former pupil of the school. The new building was completed and opened for the school year in September 1896. Here, students sit in study hall in the main building, which is currently Frost Hall. (Courtesy of Friends Academy Archive.)

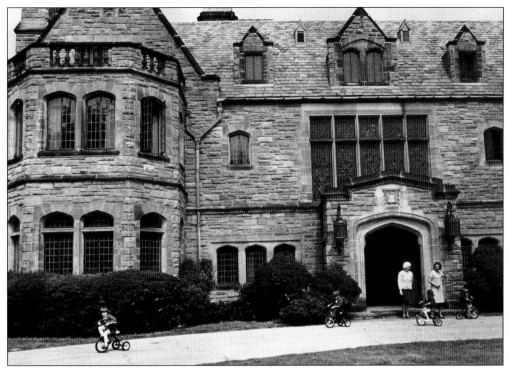

MILL NECK MANOR, SCHOOL FOR THE DEAF, 1954. In 1923, Sefton Manor was built for Lillian Sefton Thomas Dodge, president of Harriet Hubbard Ayer Company, which was one of the world's largest cosmetic firms. In 1949, Lutheran Friends of the Deaf purchased the 86-acre estate, and in 1951, Mill Neck Manor Lutheran School opened its doors to educate 19 deaf boys and girls. By 1956, Mill Neck Manor was fully accredited by New York State. (Courtesy of Mill Neck Manor.)

MILL NECK APPLE FESTIVAL, 1969. A fall harvest festival is held annually on the grounds of Mill Neck Manor in mid-October. Thousands of participants visit the campus to celebrate the change of season, to buy apples, cheese, and crafts, and to play games to benefit the programs offered by the Mill Neck Family of Organizations.

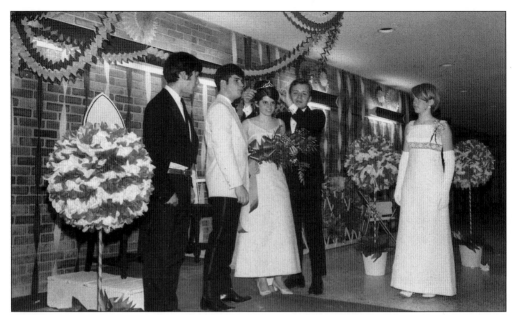

JUNIOR PROM, 1968. Junior class president Pete Durso crowns prom queen Sherry Fox while David Carroll (wearing the white jacket) and Ellen McBride look on. The boy at far left is unidentified. As Fox's date, Carroll was automatically declared "King of the Prom." "Through the Looking Glass" was the theme of the evening.

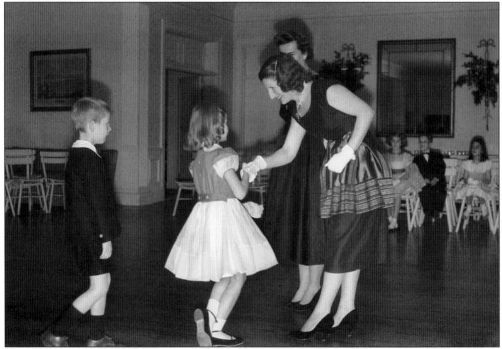

PIPING ROCK DANCING CLASS, C. 1956. Dancing class was considered de rigueur for all well-brought-up Locust Valley children. The offspring of Piping Rock Club members enjoyed expert tutelage from the esteemed husband and wife team of William and Vera de Rham. Here, a young lady curtsies to her teacher as part of her instruction.

Seven

SPORTING LIFE

A landscape of rolling hills, open fields, and natural ponds has made Locust Valley a playground for outdoor sports. Riding trails, polo fields, golf courses, tennis courts, baseball diamonds, and skating ponds abound. Whether residents participate through the public schools, community organizations, or private clubs, sports are an integral part of life in Locust Valley.

In the early 1900s, local sporting clubs sprung up in the area and were sponsored through both private and public means. One of the earliest clubs, the Firling Athletic Club, was later subsumed under the umbrella of the fire department, as was the Yellow Jackets, a semiprofessional football team. The fire department also enjoyed its own baseball team. The Matinecock Neighborhood Association sponsored many teams, notably the bobsledders, who were local champions. The Pioneer Club was a Buckram-centered men's group whose basketball team competed against other local teams such as the Forest Park Iroquois and the Locust Valley Comets. Roosevelt's Works Progress Administration paid the basketball referees. In the 1940s, the American Legion also sponsored athletic competitions for both young and old in basketball and softball.

The area is home to two exclusive country clubs, Piping Rock Club and The Creek Club, as well as Beaver Dam Winter Sports Club, the oldest winter sports club in North America. The founding fathers of the three clubs were intertwined. Beaver Dam was founded in 1911, Piping Rock was established in 1911, and The Creek Club opened in 1923. Horse shows and polo matches took place at Piping Rock, while golf and tennis predominated at the Creek Club. The collaborative team of Charles Blair Macdonald, the father of American golf architecture, and Seth Raynor designed the greens at both clubs. Beagling was another popular sport that persisted through the 1970s. Horseback riding continues today on the great maze of riding trails running throughout the old estate lands across the North Shore.

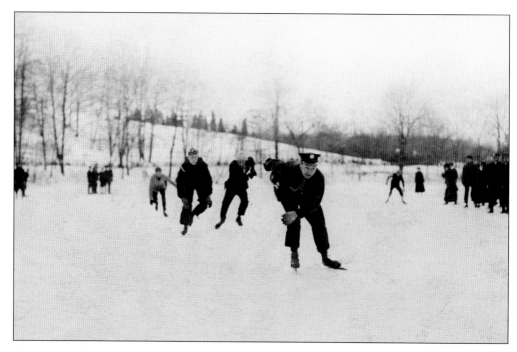

SKATING ON BEAVER LAKE. Skating is a favored local sport during the cold winter months. In 1911, Irving Cox, Paul Cravath, William D. Guthrie, and other friends belonging to Piping Rock Club founded Beaver Dam Winter Sports Club. They purchased lakeshore property from F. Coit Johnson and put up a portable house on the west side of Beaver Lake. The original club sports included skating, hockey, and curling. Briefly, there was a toboggan run that came down the hill onto the lake.

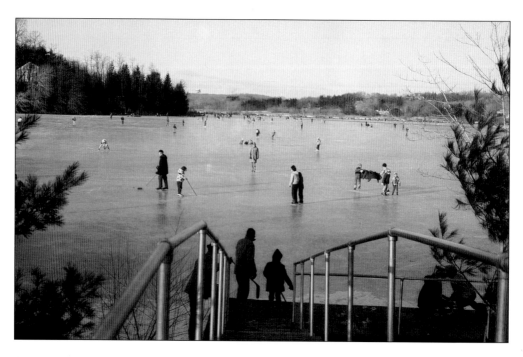

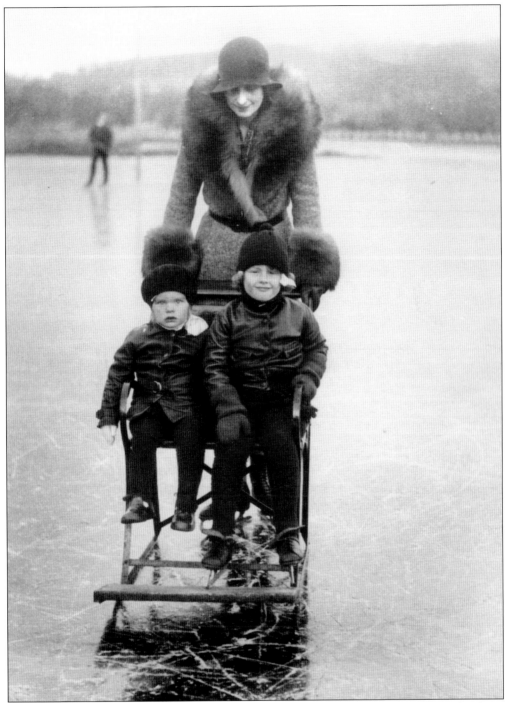

ICE CHAIR, 1931. Eunice Clapp Johnson, always the picture of elegance, pushes her daughters Eunice and Priscilla across Beaver Lake in a chair sled. Priscilla (Johnson) McMillan grew up to become a brilliant scholar and author specializing in Russian matters. (Courtesy of Eunice Johnson Winslow.)

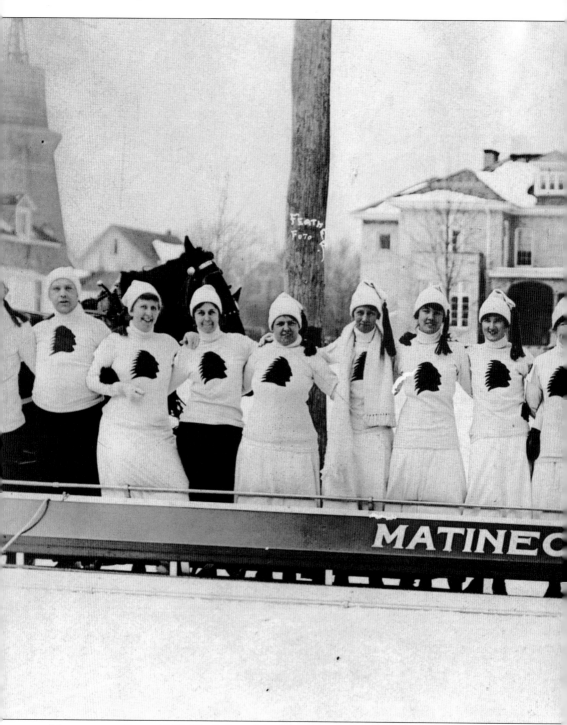

MATINECOCK CREW, 1916. The ladies of the Matinecock Neighborhood Association owned the *Matinecock* bobsled. Manned by 19 young women in Indian emblazoned sweaters, the all-woman crew won third prize at the Bob-Sled Carnival on School House Hill. A popular insult against

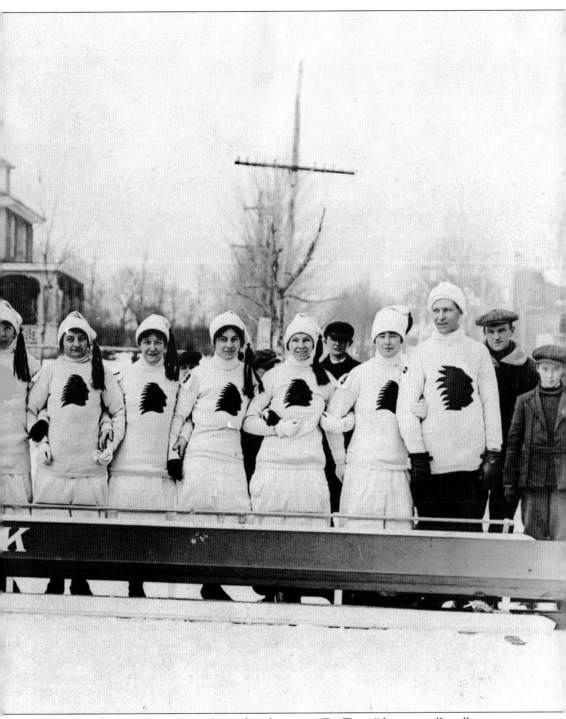

the rival Huntington team was to refer to their home as "Tar Town," because, allegedly, a man was tarred and feathered and ridden on a rail there.

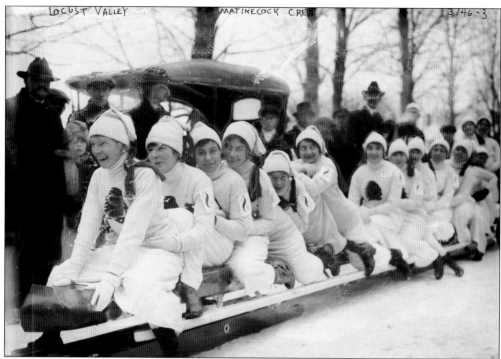

LADY BOBSLEDDERS. Locust Valley had some of the best bobsled teams in the area. On the way to competitions in Huntington, children would jump on and off the horse-drawn wagon that stopped at every saloon along the way. The wagon's route followed Piping Rock Road to Wolver Hollow and then straight down Northern Boulevard to Huntington. Bets were taken, and the saloons put up money for cups and prizes.

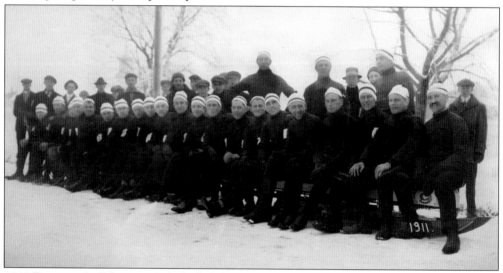

1911 BOBSLED. In February 1915, the bobsled 1911, built by Townsend Weeks and owned by the Matinecock Neighborhood Association, won a competition by a fraction of a second and was awarded with the silver cup, bronze trophy, and $50 in gold. The crew of 20 riders was lead by pilot Townsend "Ketch" Weeks, a veteran bobsled expert, in a win over the favored Tarantula. (Courtesy of Townsend W. Cardinale.)

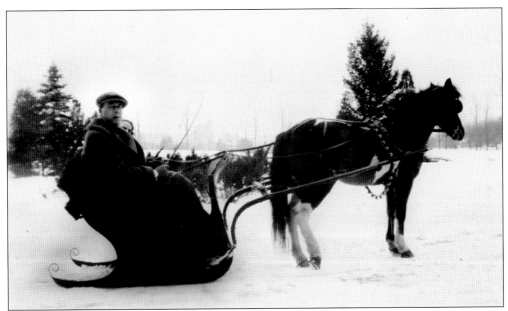

SLEIGH RIDING. In this photograph, Edward M. Ward and his sister enjoy a favorite Locust Valley winter pastime. Sleighs were used to get to and from the train station and town. The only sleigh still known to be in use now serves as a roost for the chickens on Armstrong's Farm. (Courtesy of Victoria Ward.)

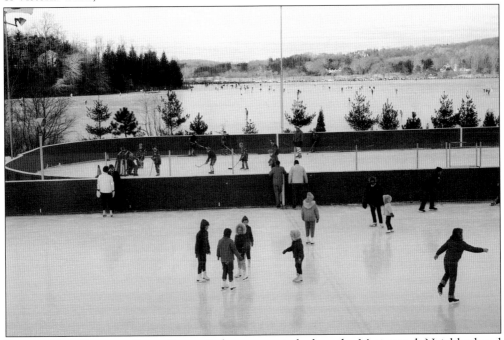

BEAVER DAM SKATING CLUB. Beaver Lake was created when the Matinecock Neighborhood Association built a dam at the foot of Feeks Lane to flood a malarial swamp. The lake was an ideal setting for winter sports, and the first clubhouse was built on the western end. The club later moved to the other side of the lake, and a full season of hockey and figure skating is still enjoyed there.

HORSESHOW BUNGALOW. In 1902, Paul Cravath, Percy Chubb, and Charles Wetmore formed the Piping Rock Real Estate Syndicate to develop the area around Locust Valley. They also joined with the North Shore Horse Show Association to hold an annual show on Piping Rock Estate grounds. Before the formation of the actual Piping Rock Club, this modest bungalow served as headquarters for equestrian events.

FIELD ENGINEERS, 1911. Engineers pose with their surveying equipment after a day of precision work during the planning of the Piping Rock Club. Two stables for 80 workhorses, a bunkhouse for 50 men, an office, tool house, and a blacksmith shop were erected near the eighth green for the construction of the club.

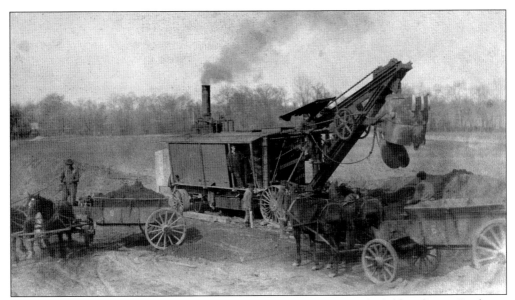

GRADING THE POLO FIELD, 1911. The creation of the two massive polo fields at Piping Rock was a mammoth undertaking that involved heavy equipment and many man-hours of hand labor. A hill was leveled and a valley was filled in to provide space for the greensward. Today, polo has given way to golf with the fields serving as a driving range.

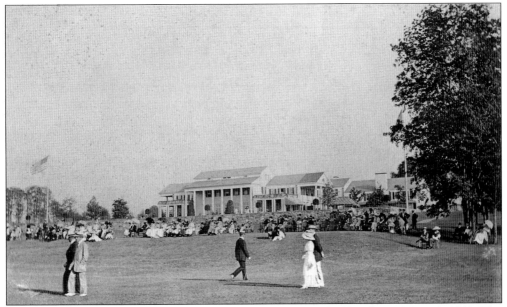

PIPING ROCK CLUBHOUSE, 1912. Piping Rock Club opened officially on May 12, 1911. The clubhouse, designed by American architect Guy Lowell, was based on American Colonial architecture and integrated into the landscape. Piping Rock had a turf track for flat races and steeplechases, a hunting course, polo fields, an 18-hole golf course, trapshooting, and courts for squash and tennis. Members enjoyed a private beach at Fox Point.

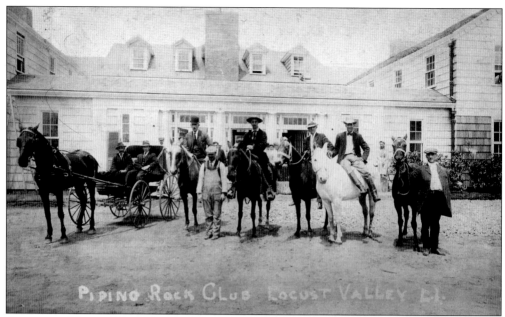

ALEXANDER HANS, 1912. Alsatian civil engineer Alexander Hans, seen on horseback in the center of this photographic postcard, worked closely with Guy Lowell and Seth Raynor to realize Paul Cravath's dream of the perfect equestrian-based sporting club. Hans, who served as superintendent, devoted his life to Piping Rock and wrote its first history.

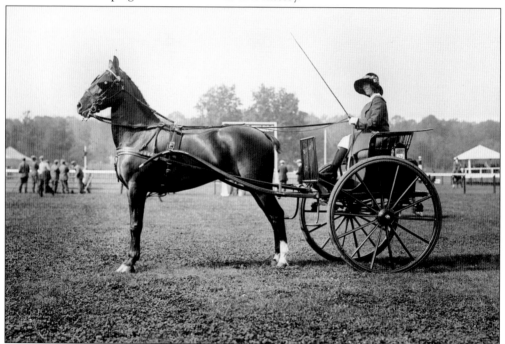

PRIDE OF JERSEY, 1912. This Bain News Service image shows Alix Dolan with the Pride of Jersey at Piping Rock Club. A *New York Times* article of October 4, 1913, notes that Dolan was one of "the younger element who showed proficiency in the saddle" at the Piping Rock Horse Show. (Courtesy of Library of Congress.)

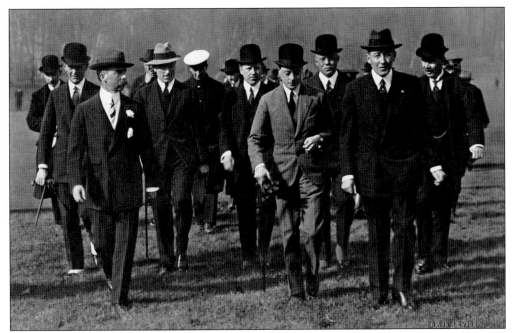

PRINCE OF WALES AT PIPING ROCK, 1914. Telegraph magnate Clarence Mackay (left), Edward, Prince of Wales (with umbrella), and club president Henry Rogers Winthrop (right) lead board members up the first fairway to the clubhouse where the Prince ceremonially planted an oak tree. The North Shore was a favorite destination of the Prince, who spent time here playing golf, visiting the George Bakers, and jitterbugging with the Grover Loenings.

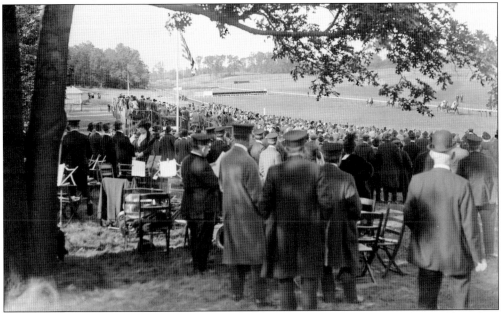

CHERRY MALOTTE WINS, 1914. Payne Whitney's Cherry Malotte, carrying Greentree Stables colors, was a leading jumper and frequent champion. Here, she is a winner, but in October 1917, she lost by a neck to St. Charlcote in the Subscription Handicap at Piping Rock in what was considered the most exciting race ever seen over a long course. (Courtesy of Library of Congress.)

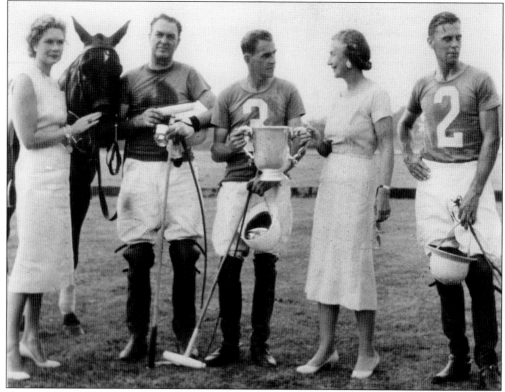

POLO AT PIPING ROCK. Polly and Henry Lewis, left, and an unidentified Polo player, far right, look on as Eunice Johnson hands Alan Corey a trophy cup. Corey, an outstanding player known for his tactical skill and horsemanship, was inducted into the Polo Hall of Fame in 1992. Polo was the glamour sport of the day and took precedence over golf at Piping Rock. (Courtesy of Eunice Johnson Winslow.)

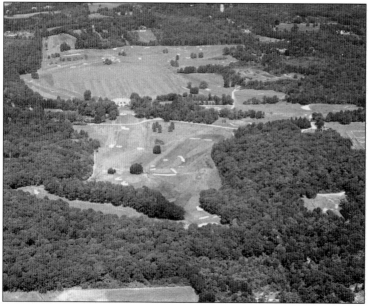

PIPING ROCK, AERIAL VIEW. When the exclusive club opened in 1912, it featured an 18-hole links-style golf course designed by Charles Blair Macdonald and Seth Raynor. Macdonald, a club member and major figure of golf in America, was never completely happy with his creation because he felt the design was compromised by the mandate to position the course around the Polo Fields.

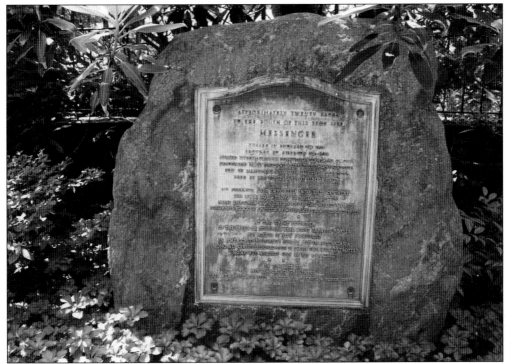

Messenger. Messenger, the legendary trotter foaled in England in 1780, stood at stud on the Cocks' farm in Locust Valley. The best thoroughbreds in America carried the bloodline of this champion racehorse, and of this steed, it was said, "None but himself can be paralleled." In 1935, a bronze plaque was mounted on Duck Pond Road in his honor.

Entrance to The Creek Club. The allée of linden trees that marked the entrance to Veraton, the former Cravath estate, still lines the road to The Creek Club. In the 1960s, the club deeded its underwater rights and land along the creek to the federal government for environmental protection and to stymie Robert Moses's plan to build a bridge across the sound.

THE CREEK CLUB. The Creek Club, founded by 11 men who were the offspring of the titans of American finance, industry, and society, was named for its location on Frost Creek. It opened in 1923, offering a Charles Macdonald–designed golf course with the 10th hole directly on the shore of Long Island Sound. Clarence Mackay was club president from its opening until his death in 1938.

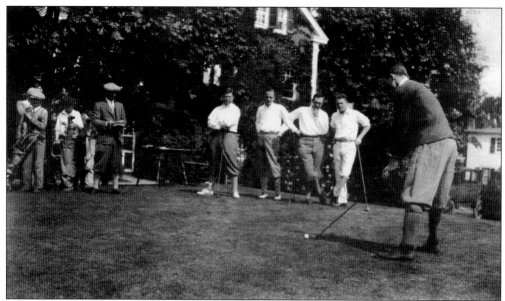

MA-BE TOURNAMENT, 1928. Englishman Jack Ross, the first golf professional at The Creek Club from 1923 to 1939, looks over a score card during the MA-BE tournament as the duffers gather round to supervise a putt. The MA-BE was initiated just for fun and is believed to have drawn its title from its originator's initials. (Courtesy of George Holland.)

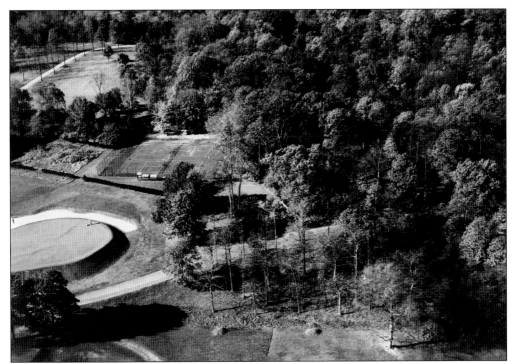

THE CREEK CLUB AERIAL VIEW, 1928. In this overview of The Creek Club, the fifth green *Lindens* can be seen on the left and behind it is the newly built tennis courts, which occupy the area that was once Veraton's formal gardens. The course was restored to its original design and reopened to celebrate its 70th anniversary on Memorial Day weekend in 1993. (Courtesy of George Holland.)

BOBBY JONES'S SCORECARD, 1930. Considered the most successful amateur golfer in the world, lawyer Bobby Jones was at the top of his form when he played at The Creek Club on August 20, 1930. The scorecard pictured shows he completed the course in 68 strokes. That year, he completed the grand slam of all four major tournaments of his era. (Courtesy of George Holland.)

LOCUST VALLEY ÷ **THE CREEK** ÷ LONG ISLAND, N. Y.

PLEASE REPLACE TURF (DIVOTS)

ATTESTED BY

DATE

Yards	Name	Par	Hole	St'kes	Self	Part.	Opp.	Opp.	Won	Lost	Yards	Name	Par	Hole	St'kes	Self	Part.	Opp.	Opp.	Won	Lost
380	Orchard	4	1								330	Shore	4	10							
350	Vines	4	2								190	Island	3	11							
360	Fairview	4	3								330	Squirrel Run	4	12							
160	Eden	3	4								421	Creek	4	13							
360	Lindens	4	5								432	Water Gate	5	14							
430	Sound View	4	6								340	Hunch Back	4	15							
520	Long	5	7								380	Oak	4	16							
190	Redan	3	8								130	Short	3	17							
386	Inferno	4	9								400	Home	5	18							
3136		35	OUT								2953		36	IN							

Players 1.

2.

| 3136 | 35 | OUT |
| 6089 | 71 | TOTAL |

"Bobby" Jones - 68 - August 20th, 1930

111

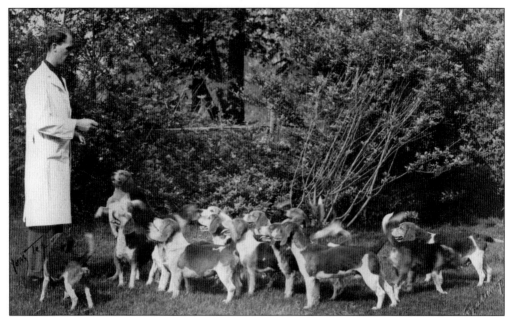

BUCKRAM BEAGLES, 1935. The year 1934 saw the establishment of the Buckram Beagles with Edward M. Ward Jr., seen here with the hounds, as the first master of the pack. This subscription pack was member owned and sported the colors green and gray. John C. Baker Jr. compiled pedigree charts and nine journals that recorded the daily activities of Buckram kennels. (Courtesy of Victoria Ward.)

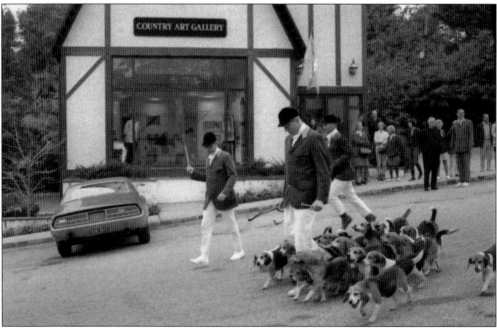

COUNTRY ART GALLERY, 1972. The Buckram Beagles gathered for the blessing of the pack in commemoration of St. Hubert's Day in front of the Country Art Gallery at the Plaza Shoppes. Clarissa Watson and Joan Payson Whitney moved their gallery to Locust Valley from an old church in Westbury when the Plaza Shoppes were built. For many years, the gallery was the cultural center of the community.

Eight

Arts and Society

For many residents of Locust Valley, the arts have always played an important role in community life. Theatrical personalities, visual artists, financiers, and royalty have all been drawn to the bucolic setting, absolute privacy, and social cache afforded by the little hamlet on the North Shore. Large-tract zoning of the surrounding countryside and a slow indirect train line have added to its seclusion and exclusivity.

The area has been home to an artists' colony, established by Marian Willard, granddaughter of William D. Guthrie, and the Country Art Galley, presided over by Clarissa Watson, who showed the work of both French and local artists. The hamlet enjoyed the Red Barn Theatre, a summer-stock venue where Hollywood greats got their start, and the Stage Coach Inn, a restaurant in the Cock-Cornelius house known for its Colonial meals and stirrup cup toasts. The region has produced a presidential candidate, a personnel director of the CIA, and the great publisher F.N. Doubleday, who was intimately involved with the development of the Matinecock Neighborhood House and the Locust Valley Library. Opera singers, inventors, and sculptors have all called this corner of the Gold Coast home.

The Duke and Duchess of Windsor were frequent guests in their day, and later, Princess Margaret and Lord Snowden visited. Cole Porter had his catastrophic fall from a horse at Piping Rock Club, and Svetlana Alliuyeva, Stalin's daughter, found sanctuary at Kaintuck Farm, where Priscilla Johnson McMillan translated her memoir. Madame Chiang Kai-Shek, once first lady of Nationalist China, summered on Feeks Lane and tens of thousands of mourners of Chinese descent came to pay homage when the Hillcrest estate sale took place in 1998.

Friends, Portledge, and St. John's Fairs, as well as the Harvest Festival at Mill Neck, are supported and attended by all strata of society. The Locust Valley Rotary's Picnic Pops and Oktoberfest, the annual sidewalk sale, and the Saturday morning farmer's market remain important local community events. In spite of its mythic glamour and international renown, Locust Valley persists as a real and beautiful place to live.

MARK TOBEY'S VISIT, 1952. Marian Willard Johnson, granddaughter of William Dameron Guthrie, showed the work of many of the most original 20th century artists in her 57th Street gallery. She is seen here with her daughter Miani on her lap, mother Ella Guthrie Rossiter, and abstract expressionist painter Mark Tobey holding her daughter Danna at her Lattingtown home. (Courtesy of Miani Johnson.)

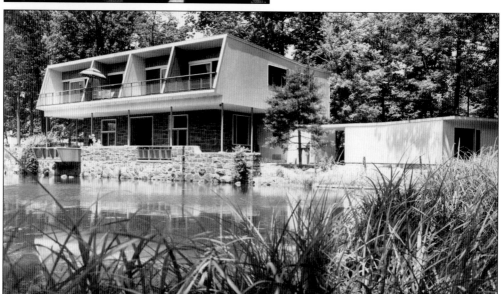

DAIRY HOUSE, 1950. The Meudon icehouse and dairy burned in 1947 and was redesigned into a contemporary residence for Marian Willard and her husband, Dan Rhodes Johnson. Among the many visitors to their home were renowned artists Alexander Calder, Morris Graves, David Smith, Norman Lewis and Joan Miro, and scholars of Eastern philosophy Alan Watts and Nancy Wilson Ross. (Courtesy of Miani Johnson.)

RICHARD LIPPOLD, 1915–2002. Richard Lippold, protege of Marion Willard, was a great American artist known for his transcendent spun-wire sculptures. He lived in a Jose Luis Sert–designed home that incorporated part of an existing estate building on the former grounds of Meudon. The spun-gold sculpture "Orpheus and Apollo," at Avery Fisher Hall at the Lincoln Center, is one of his best-known works.

RAY JOHNSON, 1927–1995. Ray Johnson, seen here on Lattingtown Beach, was a conceptual artist and collagist whose work prefigured pop art. He founded the New York Correspondence School, a pre-internet mail art network that was precursor to social networking. Despite his fame, Johnson lived in a modest cottage in Locust Valley and was active in the local art scene until his suicide by drowning in 1995. (Courtesy of Joan Harrison.)

"MADAME" ELIZABETH SHOUMATOFF. Madame Shoumatoff, as she was known, immigrated to the United States after the Russian Revolution. She supported her family and came to international fame by painting portraits of heads of state and members of prominent American families. She is best known for her *Unfinished Portrait* of Franklin Delano Roosevelt, painted on the day of his death. (Courtesy of Victoria Ward.)

ROOSEVELT PORTRAIT. Watercolorist Elizabeth Shoumatoff presented a color collotype portrait of Franklin Delano Roosevelt to the Locust Valley Fire Department as thanks for saving the original painting when her home caught fire. The portrait hangs in the firehouse to this day. (Courtesy of Locust Valley Fire Department.)

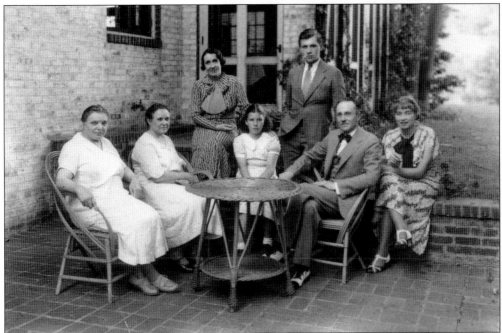

HIDDEN HOLLOW, 1945. The Shoumatoff country home off Feeks Lane was a pastoral retreat for this richly creative family. Pictured in the garden, from left to right, are family nursemaid Tatasia, unidentified household staff, Elizabeth Shoumatoff, her daughter Elizabeth (also known as "Baby") son Nicholas, brother Andrey Avinoff (a gifted painter and lepidopterist), and daughter Sophie (also known as "Zoric"), a painter and poet. (Courtesy of Victoria Ward.)

MRS. PAUL D. CRAVATH, C. 1912. Before her marriage to lawyer Paul D. Cravath, opera singer and musical comedy actress Agnes Huntington was the pet of London society. She starred in the operetta *Paul Jones*, playing the role of the macho naval hero. After her retirement from the stage, she remained active in the opera community and was prominent in local society. (Courtesy of the Library of Congress.)

LOCKJAW RIDGE. Dormer House, designed in 1913 by Theodate Pope Riddle, one of the earliest women architects in America, was renamed Lockjaw Ridge by third owner Patrice Munsel. Munsel, a wit and the youngest soprano to sing a principal role at the Metropolitan Opera, was poking a bit of fun at her neighbors' penchant for speaking effortlessly without moving the jaw. (Courtesy Collection of Paul J. Mateyunas.)

ELLA FULLER GUTHRIE. Tennis was an avocation for young Ella Guthrie, the adopted daughter of William Dameron Guthrie. Raised at Meudon, the free-spirited Ella dressed with elegance and traveled in the best circles. She married numerous times and was the mother of art dealer Marion Willard. (Courtesy of Miani Johnson.)

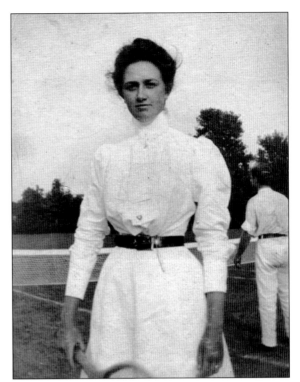

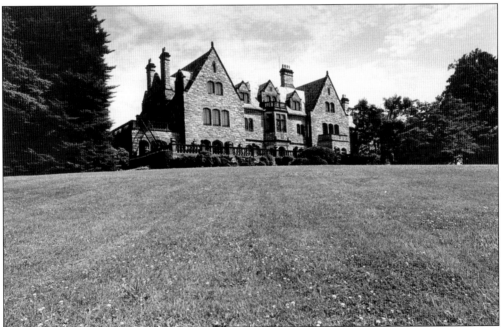

SEFTON MANOR. Former actress Lillian Dodge, upon the death of her husband, became heiress to the Harriet Hubbard Ayer cosmetics fortune and president of the company. By 1937, she was the highest-paid female executive in America, earning $100,000 a year. She sold Sefton Manor, the Mill Neck estate she shared with her second husband and only daughter, to Lutheran Friends of the Deaf in 1949. (Courtesy of Mill Neck Manor.)

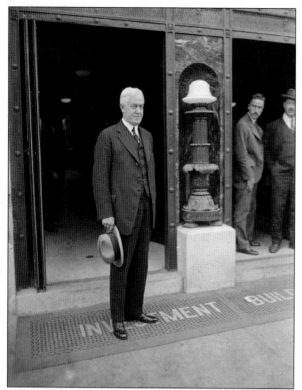

JOHN W. DAVIS, 1924. In 1924, Wall Street lawyer and former ambassador to Great Britain John W. Davis, a Lattingtown resident, ran as a dark horse Democratic candidate for president of the United States. He was picked in a record-setting 103rd ballot at the Democratic convention. After a resounding defeat by Calvin Coolidge, he retired from politics. (Courtesy of Library of Congress.)

MATTAPAN. John W. Davis lived in this sprawling white house on Overlook Road in Lattingtown. The house was named Mattapan, an Indian word that means, "where I sit." Davis was much maligned and disparaged during his presidential campaign as a Gold Coast man of wealth and privilege.

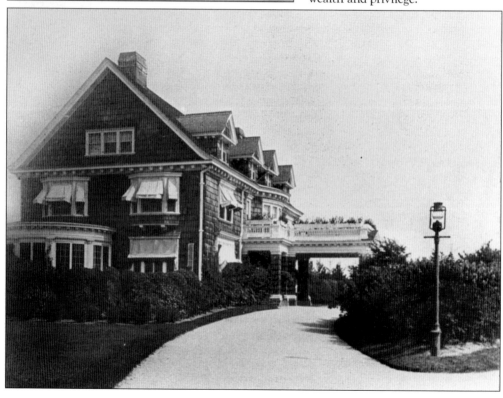

IRVING BROKAW. Lawyer, financier, artist, and author Irving Brokaw was best known as a champion American figure skater who represented the United States in the 1908 Olympics. His book *The Art of Skating* became the ice-skater's bible. He cut a dashing figure in sporting society on the North Shore. (Courtesy of Library of Congress.)

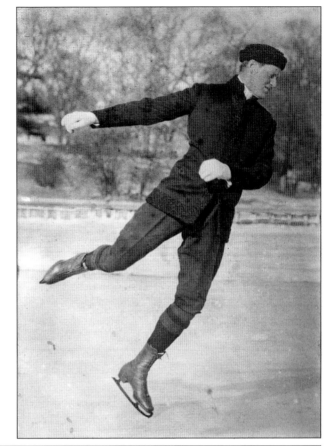

BROKAW POND. The Brokaw estate Frost Mill Lodge adjoined the ponds that flow into Shu Swamp and Beaver Lake, making up the Francis Pond subwatershed. In the 1960s, R. Brinkley Smithers acquired the property, and in 2008, Nassau County purchased the parcel from Smithers's heirs as part of the New York Open Space Plan to protect this area of rare biological diversity.

JOHN P. HUMES STROLL GARDEN. Ambassador John P. Humes and his wife, Dr. Jean Schmidlapp Humes, traveled to Japan in 1960. Upon their return, they had a Japanese Edo–style stroll garden with a teahouse created on a quiet corner of their Mill Neck estate. The garden, rehabilitated by Stephen A. Morrell and enlarged to four acres in the 1980s, is open to the public.

BAILEY ARBORETUM. In 1911, Frank Bailey, a senior officer in Title Guarantee Trust Company, and his wife, Louise, renovated an 1820s homestead to serve as their summer house. Bailey filled the 45-acre grounds with rare specimen trees and named the property Munnysunk as a satirical comment on their investment. This jewel of an arboretum is now open to the public. (Courtesy Collection of Paul J. Mateyunas.)

**PAUL GEDDES PENNOYER JR.,
1921–2010.** Paul Pennoyer
Jr. was the son of Frances
Morgan Pennoyer and the
grandson of J.P. Morgan Jr. He
was awarded the Navy Cross,
two air medals, and several
gold stars for extraordinary
heroism in the Pacific Theater
during World War II. In 2008,
his memoir *A Descendant,
but Not an Heir* was privately
published. The title refers to
the Morgan family practice
of primogeniture.

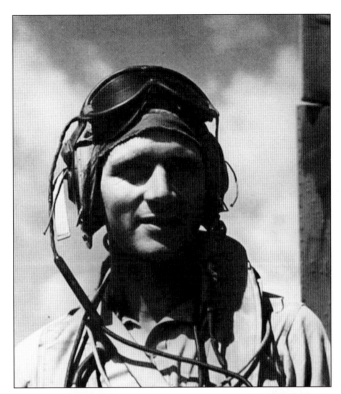

ROUND BUSH, MATINECOCK. Paul G. Pennoyer Jr. and his wife, Cecily, raised their five children
in this beautifully repurposed carriage house at Round Bush in Matinecock. J.P. Morgan Jr. gave
Round Bush to his daughter Frances Morgan upon her marriage to Paul Geddes Pennoyer Sr. The
main estate house, a victim of exorbitant taxes, was demolished after her death.

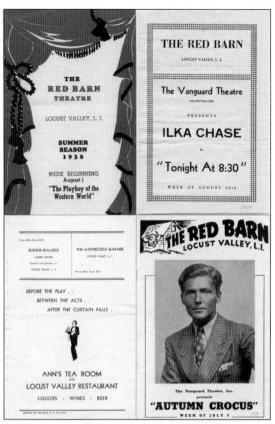

RED BARN THEATRE PLAYBILLS, 1930S. Locust Valley society turned out in evening dress to see rising stars like Jimmy Stewart perform in summer stock at the Red Barn Theatre. The venue, founded by producer Alexander Cohen, was located behind the Depot Garage; it was so close to the train tracks, performances had to be scheduled so intermission coincided with the evening freight roaring by.

STAGE COACH INN. The Cock-Cornelius House, variously a Quaker homestead, a store, and a school, became a popular Colonial-themed restaurant with nine period dining rooms under the auspices of Jane Teller Robinson. The house was furnished with rare, early-American antiques, and the stagecoach on the lawn was reputed to be one of the original Oyster Bay fleet.

EDITH HAY WYCKOFF. The *Locust Valley Leader* newspaper was founded in 1946 by Edith Hay Wyckoff, who chronicled and published the life of Locust Valley for 55 years. A passionate local historian, Wyckoff, who authored *The Fabled Past: Tales of Long Island*, made her home and kept her offices in the Cock-Cornelius house, which she named Hay Fever.

CHARLES ADDAMS, 1965. A frequent visitor to Locust Valley, cartoonist Charles Addams parks his 1933 Aston Martin on Birch Hill Road. Addams was a race car buff who also owned a Bugatti and a Bentley. His driving exploits were the subject of much hilarity and good-natured ribbing.

BUSHELL THE BUTLER. One of Meudon's impossibly correct butlers, remembered only as "Bushell," had his own sense of propriety. When traffic necessitated a stoplight being installed in front of The Creek Club, he refused to recognize it, often making for a hair-raising ride when he drove the Johnson children to school in the morning. (Courtesy of Miani Johnson.)

ARMSTRONG FARMS, PEACOCK LANE. "Eggs direct from our farm to you" is the motto of Armstrong Farms. Edward Armstrong, the last of the area farmers, is seen here standing beside the tractor he rides in the Memorial Day parade. "Eddie," as he is known to his multitude of friends and admirers, remains committed to preserving open space on the North Shore and providing his neighbors with fresh eggs.